CHINESE PORCELAIN

Anthony du Boulay

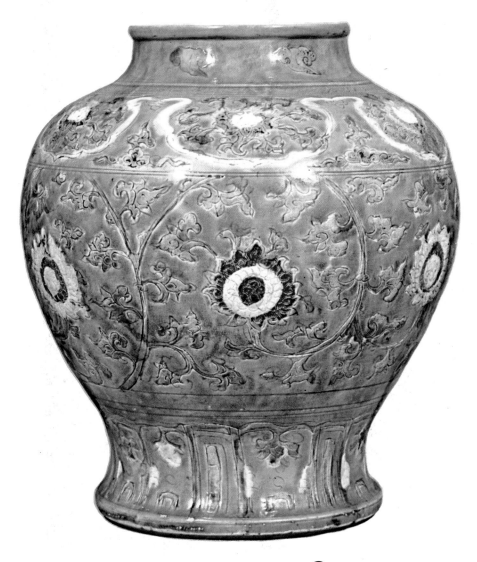

 OCTOPUS BOOKS

The author and publishers are grateful to the following individuals and institutions for permission to reproduce the illustrations mentioned against their names:

Christie, Manson & Woods Ltd, figures 2, 8, 11, 18, 23, 28, 31, 36, 43, 45, 50, 53, 54, 61, 66, 67, 68, 71, 72, 74, 76, 77, 78, 79, 80, 81, 84, 86, 87, 92, 97, 100, 101, 102, 103, 104, 105, 106, 108, 109, 110, 111, 112, 115, 116, 117, 119, 120, 123, 124, 126, 127; British Museum, 1, 5, 6, 10, 13, 17, 22, 30, 37, 56, 58, 62, 70, 94, 130, 131, 132; Victoria and Albert Museum, 34, 47, 52, 75, 90, 91, 113, 128; Percival David Foundation, 15, 16, 20, 40, 48, 55, 85, 114; Major Montagu and Lady Eileen Duberly, 14, 24, 29, 33, 39, 42, 63, 64, 65, 83, 95, 98; Seattle Art Museum 3, 4, 27; the late Mrs Walter Sedgwick Collection, 19, 35, 57; Radio Times Hulton Picture Library, 7, 25, 41; H. M. the King of Sweden, 7, 25; Marchese Dr G. F. Giaquili-Ferrini, 12; Derek Ide Collection, 32; William Rockhill Nelson Collection, Gallery of Art, Kansas City, 38; Gerald Reitlinger Esq, 41, 44, 46; Musée Guimet, Collection Grandidier, 49, 88, 89; The Lord Bruce, 73; Upholland College, Lancashire, 118; Admiral of the Fleet Earl Mountbatten of Burma, 129; Anthony du Boulay Esq, 26, 96, 99, 116; Mottahedah Collection, 121, 122; Mrs Selma Weinberg, 60; Bluett & Sons, London, 12, 21, 32, 51, 60, 69, 82, 93; Thomas Fall, London, 57; John Sparks Ltd, 129.

The following illustrations were photographed by Messrs A. C. Cooper, figures 14, 24, 29, 33, 34, 39, 42, 47, 52, 63, 64, 65, 75, 83, 90, 91, 95, 98, 113, 128.

Front jacket illustration:
T'ang horse and rider. Courtesy of Spink & Son Ltd.

Preceding page:
A Ming wine jar, covered in a three-colour glaze with an incised design, of the late fifteenth century.

This edition first published 1973 by
OCTOPUS BOOKS LIMITED·
59 Grosvenor Street, London W1

ISBN O 7064 0045 3

Produced by Mandarin Publishers Limited
77a Marble Road, North Point, Hong Kong
and printed in Hong Kong

Contents

Traditional Shapes in Chinese Porcelain
 1 Early jar
 2 *Mei-p'ing* (blossom vase)
 3 Pear-shaped bottle
 4 Wine jar
 5 Vase with ring handles
 6 Archaic handled vase
 7 Ewer of Persian form
 8 'Monk's cap' ewer
 9 Double gourd vase
10 Leys vase
11 Bulbous lipped vase
12 Square baluster vase
13 Pilgrim flask or bottle
14 Incense burner (Ting)
15 *Yen yen* vase
16 Rouleau vase
17 Bottle with slender neck
18 Conical bowl
19 Saucer dish
20 Stem cup
21 Plain bowl
22 Plain bowl with everted lip
23 Bowl with lion mask handles

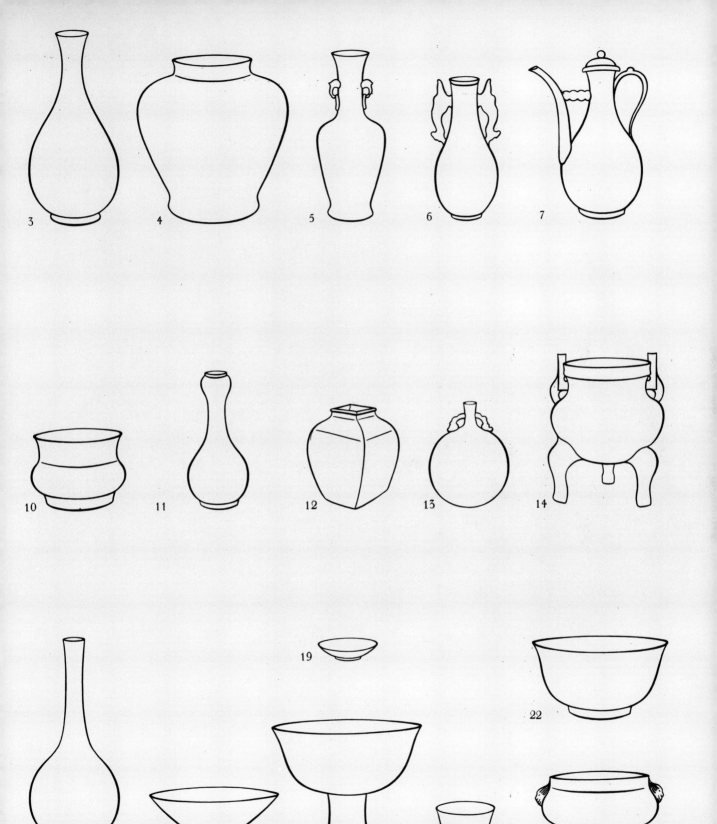

3 4 5 6 7

10 11 12 13 14

19

22

17 18 20 21 23 5

BC
1500

Shang or Yin (c. 1523–c. 1028 BC)

1000

Chou (c. 1027–221 BC) (Western Chou ended
771 BC; Eastern Chou, the spring and autumn era,
722–481; Warring States 480–221)

500

Ch'in (221–206)

0
AD

Han (206 BC–221 AD)

Three Kingdoms (221–265)

Northern and the Southern Six Dynasties
(265–589)

500

Sui (581–618)

T'ang (618–906)

Five Dynasties (907–960) and Liao (907–1125)

1000

Northern Sung (960–1127)

Southern Sung (1127–1279)

Yüan (Mongol) (1260–1368)

1500

Ming (1368–1644)

Ch'ing (Manchu) (1644–1912)

6

Republic (1912–)

The Early Wares

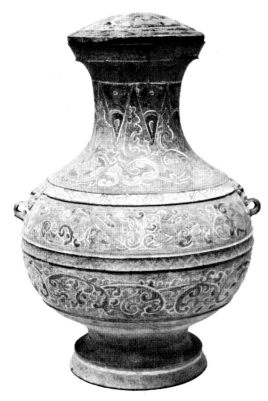

1 A funerary urn, the colours applied after firing. Six Dynasties period.

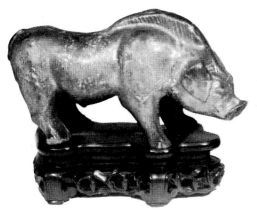

2 Pottery figure of a boar. Han tomb furniture. Long burial has caused iridescence on the green glaze.

SOON AFTER MAN HAD DISCOVERED the use of fire he found that certain clays could be baked into containers for storing food and carrying water. Gradually, as primitive civilizations were formed, he began to elaborate these vessels, not only by ornamenting their shapes but by enriching them with coloured pigments. One of the surprising things about this development is the similarity between vessels made in Europe, Asia and America at a period when there was no communication between their respective cultures.

In China a tradition of potting gradually developed over the centuries and culminated in the superb celadons of the Sung dynasty. At first, much of their finer pottery was moulded with designs copying the decoration on their ritual bronzes. One of the serious disadvantages in the use of an unglazed pottery vessel for keeping liquids is the fact that it is porous and will allow its contents to seep gradually away. (One of the advantages of this fact is still in evidence today when crocks are used for keeping butter fresh in hot weather, utilizing the cooling powers of the porosity of the container.) It was some time during the Chou dynasty (c. 1027–221 BC) that the Chinese potter first learnt the art of applying a non-porous glaze to his pot. Certainly by the third century BC vases partly covered with green-grey glazes had appeared. Figure 1 shows an unglazed, pear-shaped funerary vase of an archaic design typical of the early wares and dating from the Six Dynasties.

The first wares to have survived in any great quantity are those of the Han dynasty (206 BC to 220 AD), most of which have been excavated from tombs. The most characteristic pieces are of bronze form, covered in green lead-glazes. Many of these have acquired an attractive iridescence through burial for nearly two thousand years. Other examples of the same period which have survived from the tombs are elaborate models of buildings, animals and figures. The boar shown in figure 2 is a typical example of one of these. Like the ancient Egyptians the Chinese believed that a person should not enter the after-life and his post-terrestrial wanderings without adequate possessions. The earlier habit of sacrificing his servants and animals had by then died out, and had been replaced by putting wood or pottery models in the tomb.

It was about this time that a beginning was made in the

7

3 A T'ang dynasty glazed pottery jar in the form of a duck.

manufacture of proto-porcelain. Proto-porcelain is the word used to describe the hard stoneware which was gradually refined over the centuries into true porcelain. The origin of the word 'porcelain' is the Portuguese *porcellana*, a cowrie shell, and its use derives from the resemblance of the shell to the white porcelain from China which was being imported in the sixteenth century. A certain Odoardo Barbosa from Lisbon stated (incorrectly), after a journey to China in 1516, that ground-up shell was used as an ingredient in its manufacture. In Europe today we understand true porcelain to mean the white hard-paste translucent wares made from Kaolin and 'petuntse' clay, originating in the Far East, spreading to Germany at the beginning of the eighteenth century and to France at the end of the same century. The artificial or soft-paste porcelains are the products of the eighteenth-century French factories and the majority of the eighteenth and nineteenth-century English factories.

No such rules are recognized in China, and their early wares in particular are often merely porcellanous merging into coarse pottery. The character *tz'u* meaning porcelain has been dated to the third century AD, and the discovery of porcelain could easily

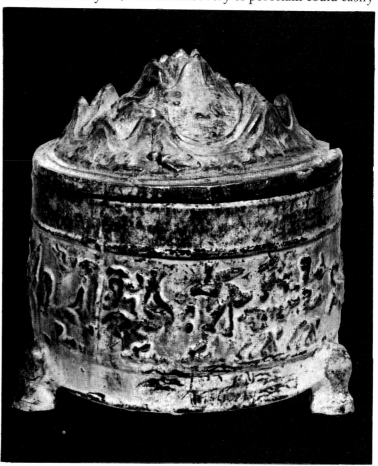

4 A 'hill' jar of the Han dynasty. Green lead glaze. $8\frac{1}{2}$ ins high.

8

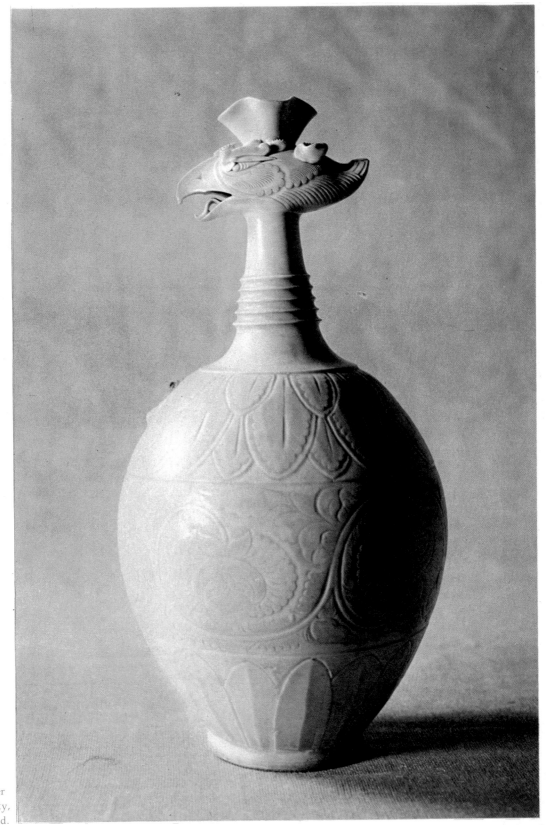

5 Yüeh ware
porcelain wine ewer
of the T'ang dynasty,
with a phoenix head.

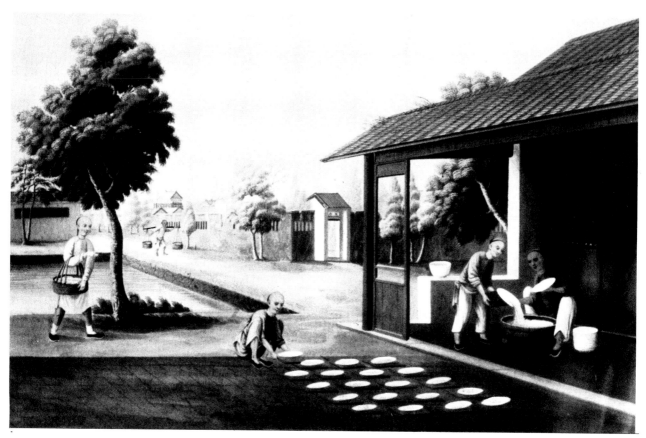

6 A water-colour painting of potters glazing and setting out their pieces to dry.

have been several hundred years earlier. The proto-porcelains are usually called Yüeh wares, from the old name Yüeh-chou of Shaohsing in Chekiang, in the neighbourhood of which a kiln site of these porcelains has been excavated. The characteristic of the Yüeh wares is a grey-green celadon feldspathic glaze over a hard porcellanous stoneware body [figure 5]. There are also vessels with olive-green glazes, decorated in imitation of bronzes.

Kaolin is the name given to the refractory clay formed from feldspar granite and pegmatite, and remains white when fired. The name is derived from the hills where it was discovered near Ching-tê-chên, which was later to become the centre of Chinese ceramic activities. Petuntse, a European version of the Chinese words *pai-tun tzû*, is a similar substance but with the feldspar less decomposed. This fused it into a kind of glass when fired. It held the less fusible kaolin together, and the Chinese referred to the kaolin as the bones of the porcelain and to the petuntse as the flesh. The glaze in which the unfired or biscuit porcelain was dipped [figure 6] was also made from petuntse. The glaze was sometimes blown on in powdered form through a bamboo pipe.

The method of making the porcelain was by carefully measuring determined quantities of kaolin and petuntse and fluxing them with water and small quantities of other substances, depending on the characteristics of the wares being made. This

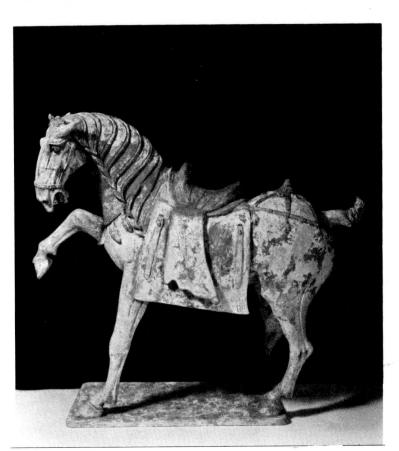

8 A T'ang unglazed pottery figure of a horse, obviously a thoroughbred ready to carry his late owner to heaven.

7 An unglazed T'ang pottery figure of a woman attendant holding a vase.

was left to mature for several years; in some cases it has been claimed as much as a hundred years, though this is unlikely. The prepared clay was then carefully kneaded to eliminate all air bubbles which could expand under the heat of the kiln and ruin the vessel or figure. The moulded or wheel-turned vessel was then left to dry for a long time, sometimes for several months. The glaze would then be applied and the piece placed in the kiln [figure 125]. The vessels were placed on sand, and many of the earlier and provincial wares still have traces of sand adhering to their foot rims. They were sometimes put on stilts and the traces left by these are known as spur marks. The wares were then stacked in covered boxes, known as 'saggers'. Depending on the temperature at which they were fired and the complexity of the piece and its decoration, the firing took from about thirty-six hours to as much as about twenty days, bringing the temperature up very slowly and allowing it to cool even more slowly.

The period between 221 and 581 AD saw the rule of numerous dynasties. The most important of these was that of the Wei which lasted from 386 to 557 AD. The pieces most commonly found are unglazed figures of both humans and animals in a hard, grey, unglazed pottery (originally brightly coloured, but now only rarely showing traces of pigment) which are usually associated with the Northern Wei period. There are also a few Yüeh vases

11

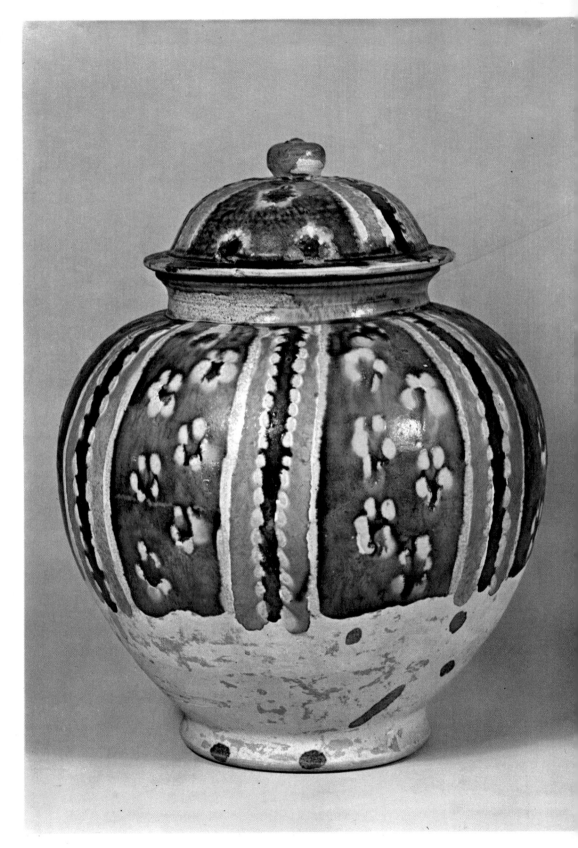

9 *(opposite)* A Honan
bottle covered in a deep
brown glaze with a
silvery brown foliage
design.

10 A T'ang *san ts'ai*
(three-colour) pottery
covered jar. The
vigorous simplicity of
the pattern is typical.

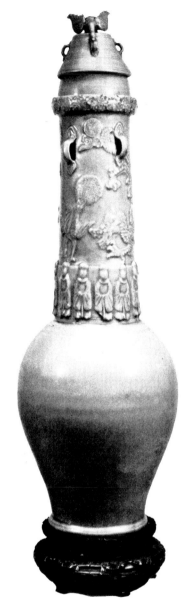

of Sassanian type whose decoration closely resembles a hunting relief cut in the rock at Taq-i-Bustan between 610 and 626 AD. These were probably made during the Sui dynasty which lasted from 581 to 618 AD.

One of the biggest upheavals in the artistic life of China came with the growth of Buddhism in the fifth century AD. It was not until then that the Chinese executed much figure sculpture, and the stone Buddhist figures carved in the caves at Yünkang in North China – one of the finest groups of sculpture in the world – point the way to these new art forms in pottery of the Sui and T'ang dynasties.

We now come to the first great period of Chinese ceramics, the T'ang dynasty. Once again the greater part of the pieces which have survived are those which have been excavated from tombs and were not known to the European market until the beginning of the twentieth century. For this reason they are often monumental in feeling and colouring. As with the preceding dynasties a large proportion of these pieces represent both human and animal figures, some glazed and some unglazed but originally decorated in brightly coloured pigments. The latter are normally made of a coarse whitish pottery, superficially resembling plaster of Paris. As a result they have been much copied by the forger in recent years. A very knowledgeable Englishman who went out to the Far East a few years ago, was shown over one of these modern workshops and, when asked to distinguish the original from the copy, was unable to do so. Owing to burial and too rough handling during excavation most of these figures have been damaged and restored, but still retain the wonderful proportions and simplicity of line which the faker finds so difficult to reproduce, as illustrated by the figure of a horse [figure 8]. The glazed figures are more difficult to copy,

11 A large Sung celadon funerary jar, with moulded relief decoration round the neck.

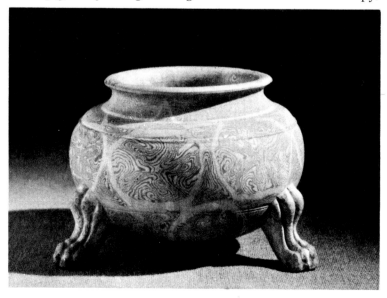

12 A T'ang pottery bowl, the decoration imitating marble.

14

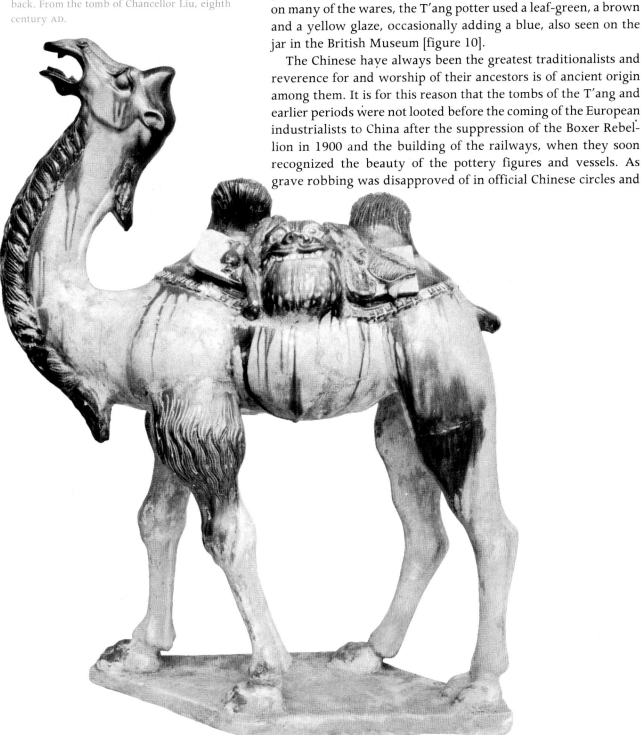

13 A T'ang glazed pottery figure of a Bactrian camel bearing its master's merchandize on his back. From the tomb of Chancellor Liu, eighth century AD.

and most of the forgeries are recognizable by the failure to reproduce the clearness of the glaze, and in particular the deeper colouring that sharply defines the margin between the glaze and the unglazed lower part, which is left on an even, white biscuit pottery. Apart from a straw-coloured and closely crackled glaze on many of the wares, the T'ang potter used a leaf-green, a brown and a yellow glaze, occasionally adding a blue, also seen on the jar in the British Museum [figure 10].

The Chinese have always been the greatest traditionalists and reverence for and worship of their ancestors is of ancient origin among them. It is for this reason that the tombs of the T'ang and earlier periods were not looted before the coming of the European industrialists to China after the suppression of the Boxer Rebellion in 1900 and the building of the railways, when they soon recognized the beauty of the pottery figures and vessels. As grave robbing was disapproved of in official Chinese circles and

15

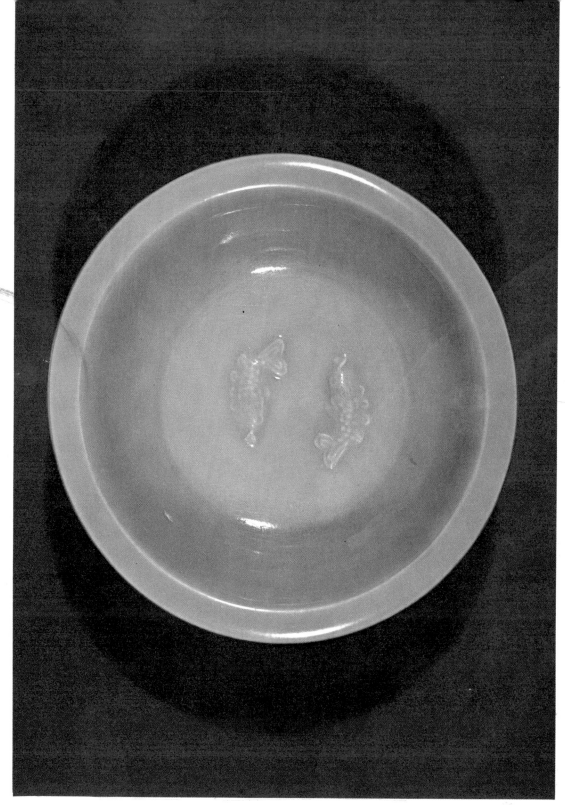

14 A Lung-ch'üan celadon dish. The centre is
modelled with twin fish, emblematic of marital
bliss.

15 Chün ware
dish of lavender-
blue with a purple
splash. Sung
dynasty.

in particular in the court of the dowager empress, most of these
pieces have reached us without any record of where they were
found and whether there were any other artefacts in the same
tomb by which they could be dated. An exception to this is the
magnificent camel [figure 13] which, with a number of other
figures also in the British Museum, comes from the tomb of
Chancellor Liu, an important dignitary who died in 728 AD.

Another important factor in the production of fine Chinese
art has been Imperial patronage. The last Sui emperor encouraged
the arts to such an extent that he bled the country white with his
extravagant building projects, but on the whole the great Chinese
emperors managed to combine statecraft with art patronage.

T'ai-tsung, the greatest of the T'ang emperors (626–649), extended the limits of his domains in the north, south and west. He unified and reinforced the Confucian laws, and his court was one of the most enlightened China has known. Foreigners and even Westerners were welcomed. It was at this period that competition in the elaboration of tomb furniture reached such a pitch that an Imperial decree was issued limiting the number and the size of the pieces that could accompany a person to his grave.

As well as the figures of prancing chargers for the late owner to ride, camels laden with his goods, graceful female dancers to distract his eyes, grooms, foreign servants and demons to protect his tomb against despoilers, vases, ewers and bowls are also found, the first normally in the form of jars, sometimes with covers [figure 10]. The upper parts are covered in beautiful yellow, blue, green and brown glazes, the lower parts showing to perfection the line of contrast between the glaze and the white pottery vase. These are sometimes covered in glazes imitating agate and other marbles [figure 12]. The dishes are often carved with designs in *cloisonné* technique, the raised parts forming the divisions between the different colours. A number of the ewers are of Near Eastern type recalling Sassanian originals with applied figure moulding.

In the ninth century the T'ang dynasty began to decline and was finally brought to an end in 906 AD. The next fifty-three years are known by the name of the Five Dynasties, during which time rival princes and generals seized power in different parts of the country, eventually to be united under the first Sung emperor. By this time the boundaries of China had shrunk considerably under the invasion of the Tartars.

16 A Ju ware incense burner of archaic bronze form, from the Sung dynasty.

At the beginning of the T'ang dynasty the manufacture of wares of Yüeh type was moved from Chiu-yen to Shang-lin-Hu. The porcelain was of finer quality, and many of the pieces have a superbly chiselled design of lotuses, waves, dragons and phoenixes. The glaze was normally a clear celadon with browny-olive overtones. The forms included bowls, boxes, dishes and the magnificent phoenix-headed ewer [figure 5].

The Sung dynasty has been called the classic period of Chinese art, and it has been said that the true collector of porcelain should end his life possessing only a single piece, a white Sung bowl of perfect proportions, entirely without decoration. First we must look at the historical background. The Mongol invaders were firmly established across the trade routes to the north and west and the Chinese culture and rule were confined to a smaller part of China than before. The first Sung emperor was a general, as were most of the rulers in the fifty years following the dis-integration of the T'ang, and he consolidated the government into a central bureaucracy and abolished the military governor-ships on the frontiers. As a result, the importance of the Civil Service and the merchants became more marked and the Chinese reverence for their ancestors came once more to the fore; this was reflected in their love of past works of art in jade, bronze and pottery.

From 960 to 1126 the government was settled in Kai-fêng, but in the later year a great tragedy hit the Sung. The emperor Hui Tsung was captured by the Chin Tartars in his own palace. His successor was left only with the provinces south of the Yangtze and with a new capital at Hang-chow.

The period is famous for its celadons, white and deep brown glazed wares. The most important are naturally the most rare, having been made specially for the emperor and his court. The figures of humans and animals for which the T'ang dynasty is so famous had almost entirely ceased to be made, owing to changes in burial customs.

18 A Lung-ch'üan celadon vase, possibly of Sung but more probably of Yüan date.

JU WARE

This is reputed to have been made only between the years 1107 and 1127 at the capital Kai-fêng in Honan. The body material is an extremely fine and soft buff stoneware. It is covered in a fairly thick opaque glaze of a soft bluish-grey colour, ranging from pale lavender to duck-egg blue. It is usually crackled and certain pieces are discoloured by fire, perhaps in the famous Imperial Palace fire which occurred during the reign of Ch'ien-lung. The foot rims are often slightly splayed, and are glazed over, revealing spur marks on which the pieces were fired. Until now there are only about thirty known pieces of this ware in existence and the largest collection is in the Percival David Foundation, London [figure 16].

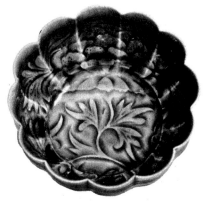

19 Northern celadon bowl carved with a foliage design under the glaze.

20 One of a famous pair of dated blue and white baluster vases in the Percival David collection, London. The date, 1351, is important in the study of the chronology of blue and white design.

21 A Sung *ting-yao* dish decorated with incised scroll design.

KUAN WARE

Kuan means 'official' or 'imperial' and refers to all those wares of high quality made in the official kilns of Hangchow after the transfer to the south. The earliest and finest wares were produced in the kilns installed near the Palace between about 1130 and 1160. Later, owing to the further advance of the Mongols, this factory appears to have been closed down and the court began to patronize the public factory named 'Chiao-t'an' (suburban altar). The characteristics of the ware are a thick and bubbly glaze with a dullish finish, often applied in layers. They sometimes have a deliberate crackle and this ware is then often known as 'Ko'. These were often copied by the eighteenth-century imitators, particularly with white or grey grounds. The colour of the *Kuan* glazes varies considerably from an almost white monochrome through grey, and sometimes tending to blue and green [figure 17]. The form of the pieces is usually traditional but some freer forms are known, particularly certain examples in the David Foundation. The glaze is quite different from the northern Ju and it has a dark-coloured body, although there are pieces of *Kuan* type with a lighter body which may come from other kilns.

CHÜN WARE

This comes from a number of sites in Honan and varies considerably in quality, with both Imperial and non-Imperial wares. A considerable number of pieces of this ware date from a later period than the *Kuan* wares and can be attributed to the Yüan and even the early Ming dynasties. The characteristics of the ware are a thick, opalescent glaze of a lavender colour, sometimes with purple splashes due to an accidental or intended addition of copper during the firing [figure 15]. There are two types of body, the first, a fine grained, light grey porcellanous stoneware, the second a coarse buff or reddish stoneware. The former is used for the Imperial bulb bowls and often bears marks resembling the tracks of an earthworm. The bases are covered in an olive-brown wash and have spur marks, sometimes with a numeral from one to ten incised. In the coarser wares the glaze lacks the purity of colour, particularly around the borders, and collects into large blobs, leaving the lower parts of the bowl or dish unglazed. There is also a celadon Chün glaze known as green Chün. Another form, known as soft Chün or Ma-Chün, has a waxy appearance and is minutely crackled. It has the normal thick and opalescent lavender glaze, sometimes finished with purple. This is almost certainly not of Sung date, but probably originated during the Yüan dynasty, continuing under the Ming.

Chün-yao is the ancestor of the Kuangtung stonewares which continued to be made throughout the Ming and Ching dynasties. This lacks the opalescence of the Chün glaze, but produced the majority of the eighteenth-century monochromes with stoneware bodies, such as the *sang-de-boeuf*.

22 Ting ware dish carved with a design of phoenix and flowering plants under the glaze.

TING WARE

This was amongst the first true porcelain ever made, being a translucent orange when held against a strong light. It is completely different from the wares already discussed and is covered in a thin colourless glaze, often with an ivory tinge. The pieces were normally fired upside down and often had bronze sheaths added to protect the unglazed rims. As a result the thin foot rims are normally glazed. Many of the pieces are quite plain, but sometimes they have either finely incised or moulded decoration which is surely but sketchily done to produce the impression of flowers, birds and fish [figures 21, 22]. The details are often executed to give a combed effect. The earliest wares were produced in the north and an important site was discovered by Dr Koyama at Chien-tz'û-ts'un in 1941 in central Chihli. As well as many fragments of the white-glazed ware, he discovered pieces with red and black glazes. Stoneware of Tz'u-chou type was also made in this kiln. It appears that these two types of ware were made side by side and with complementary usages. After the court fled to the south, some of the Ting potters are supposed to have moved south and set up their kilns in the district of Chi-chou in Kiangsi. Today no one can distinguish with certainty between the northern and southern Ting, but a group of scholars has tentatively put forward the suggestion that the earlier pieces appear much more yellow when seen through transmitted light. The forms of the Ting ware are the classic ones, *mei-p'ing* (a baluster vase with a narrow lip), bottles with everted lips, stem cups, saucer dishes, lobed bowls, shallow bowls as well as boxes, ewers and water pots.

NORTHERN CELADONS

These were probably made at several kilns in Honan, although none has definitely been identified with the exception of some kiln-wasters found at Ta-ying-chou. There is a definite resemblance in design between these pieces and those classified as *ying-ch'ing* or *ch'ing-pai*. They are a thinly potted, grey porcellanous stoneware covered in a translucent olive-green celadon glaze. The bowls have small, thin foot rims burnt a buff-brown and are often conical in form. There are also saucer dishes, sprinkler vases, boxes and ewers. The lobed bowls and ewers are normally undecorated but many of the other pieces have fine combed and carved decoration of ducks swimming, foliage and figures [figure 19].

LUNG-CH'ÜAN CELADON

Although there were kilns at Lung-ch'üan in the southern extremity of Chekiang province in the Ch'u-chou prefecture before the court moved south, it was not until this period that it started to make its finest wares. The stoneware body is light

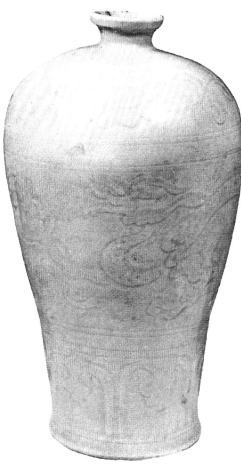

grey in colour turning into a pale buff when exposed, and the glaze in thick and viscous. It is sometimes crackled with a wide net pattern. The colour is obtained by the iron in the glaze and the texture of the surface reminds one of pale green jade [figure 14]. There are a number of vases of mallet shape which are highly prized by the Japanese. These are covered in a smooth and even glaze of bluish tone and the Japanese call pieces with this glaze *kinuta* (mallet) after these vases. Though they are still making porcelain of this type today at Lung-ch'üan, many of the potters are supposed to have moved to Ch'u-chou during the Yüan dynasty, which subsequently became the centre for the manufacture of these celadons. The Ch'u-chou celadons continued right through the Ming dynasty and many pieces have survived to this day, due to the great strength of the material with which they are made [figure 24]. Like many of the earlier lung-ch'üan celadons, they often have a carved design of scrolling foliage waves and stiff leaves, the unglazed parts usually being burnt a bright orange. These celadons were also made at Hang-chou, from where pieces are more heavily crackled than those of Lung-ch'üan and are nearer to the *Kuan* wares. They are possibly the classical *Ko* wares of Chinese literature.

YING-CH'ING WARES

This means 'shadowy-blue', sometimes called *ch'ing-pai* (blue white'), and is a very beautiful but fairly common Sung porcelain. It is not listed amongst the Chinese classical wares, but one would like to think that there may be a connection between these and the legendary Ch'ai ware described as being 'blue as

23 A *ying-ch'ing* blossom vase *(mei-p'ing)* with main design of a dragon incised under the glaze. Yüan dynasty.

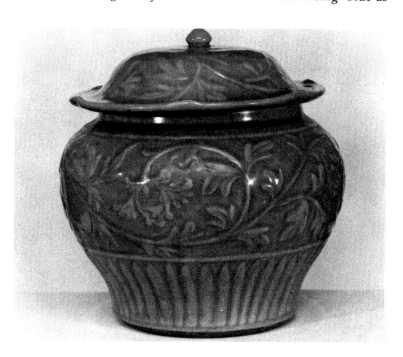

24 Yüan dynasty Lung-ch'üan celadon wine jar and cover, carved with a foliage design under the glaze.

24

the sky at a rift in the clouds after rain' and 'bright as a mirror, thin as paper and resonant as a musical stone'. It has a thick translucent porcelain body of white colour, turning slightly red when exposed. It is covered in a pale blue white glaze, turning deeper in the hollows and in the bases of bowls. It has a soft glaze and many surviving pieces are very rubbed. Like the Ting wares, the bowls and dishes were often fired upside down and have metal sheaves round the rims. The bases are usually glazed and the foot rims resemble those of the Ting wares. The forms are similar to those already described and the decoration resembles the northern celadons, though a stippled design is peculiar to these wares. It was apparently made in various parts of China, but the majority of sites were in Kiangsi near Ching-tê-chên, which became a city devoted to the manufacture of porcelain under the Mings, and it was almost certainly from the *ying-ch'ing* porcelain that the early blue and white was developed. The *mei-p'ing* [figure 23] was bought shortly before the war for under £20, and was sometimes used by its late owner for its original purpose of displaying a single branch of a flowering tree. Its value having greatly increased, it was recently sold for over £2,000. (Today, this would be over £20,000.)

SHU-FU WARE

Shu-fu ware was not produced until the Yüan dynasty but is closely related to the *Ying-ch'ing* wares. The kiln sites are also near Ching-tê-chên. The glaze is the same colour as *Ying-ch'ing* but more opaque, the decoration is in low relief and usually incorporates the characters 'Shu-fu' (whence its name) as well as flowers and phoenix. *Shu-fu* means 'central palace' and it must have been an official ware of its period. It is also closely related to the early blue and white.

CHIEN WARES

Chien ware, called temmoku by the Japanese, refers to those pieces from Fukien in southern China. It consists almost entirely of small conical bowls covered in dark-brown glazes, usually mottled or streaked with dark silvery-blue markings called 'hare's fur'. The glaze collects round the lower part of the body, leaving an unglazed base of dark brown stoneware. These wares were exceedingly popular in Japan from the thirteenth century when the tea drinking cult was introduced, and were soon copied in other provinces, especially Honan, Chihli and Kiangsi, where they introduced varieties by mixing glazes containing different oxides.

HONAN WARES

The Honan potters introduced, probably accidentally, the 'oil spot' glaze where the dark surface is covered with tiny silvery

25 A Honan 'oil spot' ewer of the Sung dynasty.

spots [figure 25]. They also used a white fillet of clay often taking the form of vertical ribs or horizontal borders. Another effect was to apply an oxide over the unfired glaze to give a tortoise-shell appearance or the impression of birds or flower sprays [figure 9]. The Chihli wares have been found at the sites of Chü-lu-hsien and Ching-ho and are similar to those from Honan. The black wares of Kiangsi centred round Kian and are so called. The body is a buff stoneware covered in a somewhat lighter brown and less lustrous glaze. They are often decorated with designs of birds or flowers in a darker brown, showing a considerable control in the kiln transformation. Another effect was caused by placing a leaf on the bowl while it was in the kiln, which left an impression on the glaze.

TZ'U-CHOU WARES

These are rather different from any of the wares already described and belong to the north. Tz'u is a district in the south-west of Chihli and is still a centre of ceramic production. The body is a heavy stoneware and there are four different types. The first is broadly and freely painted in dark brown or black on a white ground; the second is made by washing the piece over with a thick glaze and then cutting through it before firing, thereby obtaining a pattern of biscuit against a glazed ground; the third is made by incising a design on the body of the vessel and filling it in with a contrasting colour; and the fourth is enamelling in red, green and yellow over the glaze. This last method has up to now been considered to date back to the Sung period, but it is possible that it was not begun until the Ming dynasty. As already mentioned, Ting and Tz'u-chou wares have been found together on the same sites, and at Chü-lu-hsien in Chihli, a town which was inundated when the Yellow River broke its banks in 1108 AD. The body is a buff or grey stoneware, covered in a white slip with a colourless glaze. The pieces excavated have been stained by burial in damp ground. The shapes of Tz'u-chou wares are more monumental than most of the other wares and include large jars and *mei-p'ing* (blossom vases). Figure 34 shows a *mei-p'ing* of Yüan or early Ming date painted with hares in black and then covered in a turquoise glaze. A development of this technique will be found in the 'fa hua' wares discussed in the next chapter.

Before passing on to the Yüan and Ming dynasties it is necessary to mention a few wares which were produced in parts of the country not under the control of the Sung emperors. After the fall of the T'ang dynasty in 906 AD a nomadic people called the Kitan occupied the region with Jehol as capital until 1124, and took the dynastic name of Liao. They carried on the T'ang technique with three-colour wares on a pinkish pottery ground as well as monochrome pieces with applied decoration. Many

26 A Korean celadon cup-stand, twelfth or thirteenth century.

27 A Tz'u-chou ware pillow. The top has a landscape and figure design, the sides panels of foliage. Sung dynasty.

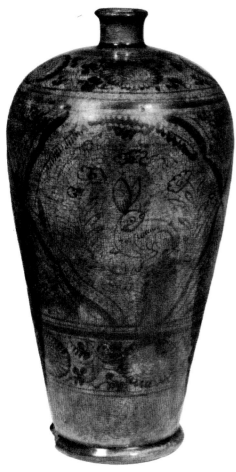

28 A fine Tz'u-chou *mei-p'ing*. The crackled turquoise glaze covers a design in which a hare is the central motif. Yüan or early Ming.

pieces can be seen to have their origins in silver, in particular those with incised decoration. Water bottles are also frequently found, copying the leather originals and showing the nomadic origins of the Liao people.

The second are the Korean celadons produced at the same time as the Sung. These are most attractive and closely follow the Sung forms. The celadons are normally of a bluish-grey tinge and often crackled. The foot rims are low, rounded and glazed, which necessitated the use of the spurs whose remains are characteristic of these wares. They often have coloured slip-decoration applied to make the finely incised designs clearly visible through the somewhat opaque glaze.

The third are the provincial wares of Siam known as Sawankhalok. They are also attractive but normally coarser than the Chinese wares. The celadons are browny-olive in tone and very crackled. A common form is a globular bottle with two handles to the short neck.

In 1279 the last Sung emperor was overthrown by the Mongols and the Yüan dynasty of Kublai Khan began. The Yüan carried on the techniques of the Sung kilns, and it is often difficult to be sure whether a piece is of Sung or Yüan date. There is, however, one very important step in the history of ceramics which began under the Yüan: the introduction of porcelain decorated with blue (cobalt) or red (copper) under the glaze, from the Near East. The first potters to discover the art of painting in blue under a transparent glaze were the Persians at Kashan. The blue underglaze decoration was almost certainly developed from the *ying-ch'ing* and *shu-fu* wares and there are a number of small jars, bowls and stem cups with *ying-ch'ing* type glazes painted in underglaze blue with freely drawn flowering branches or dragons which are usually dated to the first half of the fourteenth century, but which could be later provincial wares. Some at least must be the earliest experimental pieces of blue and white, although the situation has been further confused by modern fakes, with artificial traces of burial, simulating these pieces. The drawing on the copies is, however, somewhat stiff and unnatural. They are far removed from the important pair of vases in the Percival David Foundation which bear the cyclical date for 1351 [figure 20], and on which are based our present ideas of dating early blue and white.

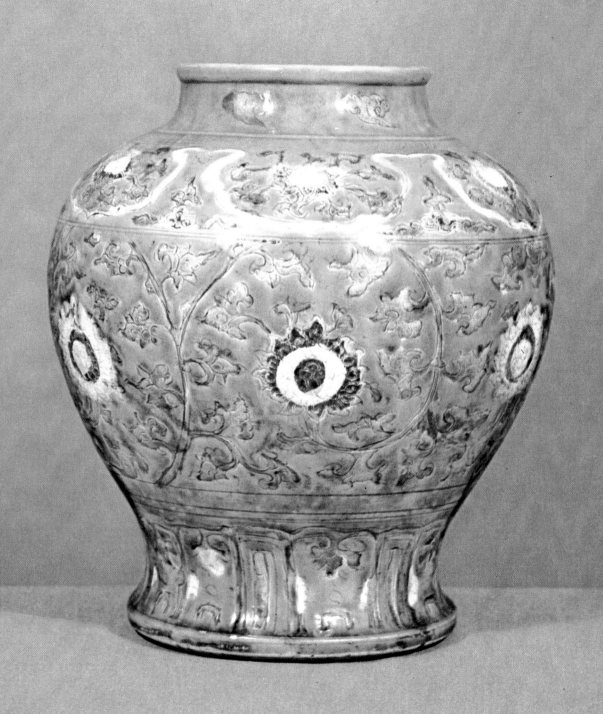

The Ming Dynasty (1368–1644)

WHILE I HAVE REFERRED TO THE SUNG DYNASTY as the classical period of Chinese art, the Ming dynasty could be called the Baroque period. Massive forms, intricate designs and bright colours are typical of Ming ceramics, although it must not be forgotten that most of the late Sung ceramics were carried on well into the Ming dynasty.

Ching-tê-chên became the ceramic centre of China and enjoyed Imperial patronage from about 1400 AD until the first Chinese Republic in 1912. The greater part of the porcelain was produced either in Ching-tê-chên's Imperial kilns or in the many private kilns which sprang up around them. When the native Ming drove out the Mongols in 1368, they set up their capital at Nanking and their leader, Chu Yuan-chang, once a Buddhist monk, was crowned emperor as Hung Wu. He founded the Ming dynasty on the model of the T'ang, and although he reigned for thirty years the whole of this time was spent in completing the overthrow of the Mongols. As a result, probably not much Imperial porcelain was made during his reign, though many of the late fourteenth-century underglaze red and blue pieces as well as thousands of celadon wares almost certainly belong to his time, but only a very few pieces bearing dates between 1368 and 1400 AD can be said to be authentic. However, the traditional style of blue and white must have been carried on and one can trace a certain logical sequence, particularly in the large pieces of the fourteenth and fifteenth centuries. On the David vase [figure 20] one can see a characteristic border pattern of waves with stray dark outlines resembling leaping animals, which can also be seen on the neck of the vase in figure 30. At this time the drawing was strong and with characteristic spiky leaves in a darkish blue, enriched with blackish spots [figures 30, 32]. This was caused unintentionally, whilst on the eighteenth-century copies the spots can be seen to have been applied deliberately. It is very aptly described as having a 'heaped and piled' effect. The porcelain itself is heavily potted and the bases are usually unglazed and burnt orange.

Pieces of this date are very rare and command high prices today, but it is only very recently that they have been truly appreciated. The large vase [figure 30], now in the British Museum, was discovered on the top of a cupboard in an East Anglian home not long ago, and although its previous history is

30 Early Ming blue and white wine jar of the fourteenth century.

29 *(opposite)* A Ming wine-jar, covered in a three colour glaze with an incized design, of the late 15th century.

年製 洪武　年製 永樂　德年製 大明宣　化年製 大明成　治年製 大明弘　德年製 大明正

Hung-wu
(1368-1398)

Yung-lo
(1403-1424)

Hsüan-tê
(1426-1435)

Ch'êng-hua
(1465-1487)

Hung-chih
(1488-1505)

Chêng-tê
(1506-1521)

Ming Dynasty Reign-Period Marks

unknown it could have been bought for very little, even shortly after the last war. This vase, like most of the blue and white of this period, must have come from the Middle East, as its silver rim is of Turkish origin. The dish painted with a carp [figure 32] also has the typical spiky leaves round the border. The important *mei-p'ing* ('blossom vase') in Kansas City [figure 38] bears the mark of, and dates from, the reign of the Emperor Hsüan-tê (1426–1435), and with the vine dish [figure 31] illustrates the change of style from the fourteenth century to the fifteenth. The characteristic blackish-blue with dark spots in still there, the sure drawing also, but the wave pattern has become lighter, more stylized and less naturalistic, the dragon is more sinuous and his scales more supple. (It is interesting to note that throughout Chinese art both the dragon's eyes are nearly always shown, even when the dragon is drawn in silhouette.) The leaves are no longer spiky.

At this time a series of 'lien-tzu' or lotus-pod bowls appear. These are decorated with interlaced strapwork derived from the lotus, and have deep, almost conical, bases. Those with marks date from the Hsüan-tê period, but those without appear to be earlier. The bases of the latter have pointed centres, and are attributed to the reign of Yung Lo (1403–1424), the fourth son of Hung Wu and the uncle of Chien-wên (1399–1402). As Prince of Yen, Yung-lo rebelled against his nephew and burnt the palace to the ground. The empress perished in the flames but the young emperor is reputed to have escaped and became a wandering monk until the accession of his first cousin, Hsüan-tê, who allowed him to live peacefully in part of the Imperial Palace until his death. Another type of painting attributed to the beginning of the fifteenth century are the skilful drawings of sages in landscapes, conversing, in contemplation or with boy attendants. These are simply drawn with the minimum number of strokes necessary to produce the effect.

The quality of the blue varied considerably throughout the

31 A fifteenth-century dish, the centre with a design of scrolling vines, the cavetto with a design of peonies and scrolls. The pattern on the rim band is of breaking waves.

30

靖年製　大明嘉　慶年製　大明隆　曆年製　大明萬　啟年製　大明天　年製　崇禎

Chia-ching
(1522-1566)

Lung-ch'ing
(1567-1572)

Wan-li
(1572-1620)

T'ien-ch'i
(1621-1627)

Ch'ung-chêng
(1628-1644)

Ming dynasty, because the supplies of imported cobalt were uncertain and the locally mined cobalt was of much inferior quality. In 1405 Yung-lo sent out a fleet under the eunuch Cheng-ho which visited many of the islands of the East Indies as well as India itself. Intimidated by the size of the fleet – sixty-two large sailing vessels carrying 27,000 soldiers – several independent states sent tributes and envoys in token of submission. Amongst these tributes was a quantity of Sumali blue, brought by ambassadors from Sumatra throughout the Hsüan-tê period. In the eyes of the Chinese experts this was the period that produced the finest blue and white ever made. The mark was frequently copied and many of the pieces formerly attributed to this period have been proved sixteenth-century in date or later. The collection formed by the Sultans of Turkey and now exhibited in the former kitchens of the Harem at Istanbul, the Topkapu Sarayi, is the most extensive in the world. The first record of this collection occurs in an inventory dated 1504 which refers to twenty-one pieces. Today there are thousands, including a remarkable collection of fourteenth-, fifteenth- and sixteenth-century blue and white, as well as thousands of pieces of Ming celadon.

After the death of Hsüan-tê at the early age of thirty-six he was succeeded by his nine-year-old son, Ying Tsung, under the title of Chêng-t'ung. For the first fourteen years of his reign he was merely a puppet in the hands of the dowager empress and the chief eunuch, Wang Chen. The later was killed and the emperor taken prisoner by the Tartars at T'u Mu in 1449. They held him for seven years, during which time his brother reigned as the emperor Ching-t'ai. On his release Ying Tsung was put back on the throne by a *coup d'etat* and took the title of T'ien-shun. Probably very little porcelain was made in the imperial factories during these troubled times, though the provincial factories must have continued the manufacture of pieces in large quantities. A few of these pieces have survived with

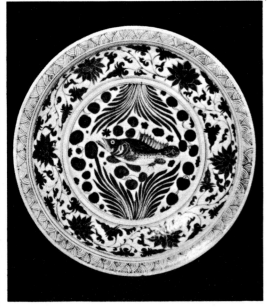

32 A fourteenth-century Ming blue and white dish, painted with a carp and water-weeds.

31

inscriptions or cyclical dates. There is a fine white stem cup decorated with animals bearing the incised mark of T'ien-shun, which was probably made shortly before his death and the succession of Ch'êng-hua.

Hsien Tsung, eldest son of T'ien-shun, ascended the peacock throne as Ch'êng-hua at the age of seventeen in 1465. He was a weak man, swayed by his favourites and by his mistress the Lady Wen. She, however, took a great interest in the porcelain factory, and the Ch'êng-hua porcelains stand in the greatest esteem in both Chinese and European eyes. The blue and white, however, is not as strong as that of the Hsüan-tê period because the supplies of cobalt brought by the Sumatran envoys were now exhausted and they were obliged to use the somewhat thinner local cobalt. Perhaps for this reason, genuine examples from this reign are very hard to distinguish. Most of the pieces, accepted as being Ch'êng-hua thirty years ago, have now been relegated to the sixteenth, seventeenth and eighteenth centuries. We are, however, fairly sure of the types which could have been made

33 Two yellow-ground dishes: that on the right is a Ming original, and that on the left a Ch'ien-lung copy.

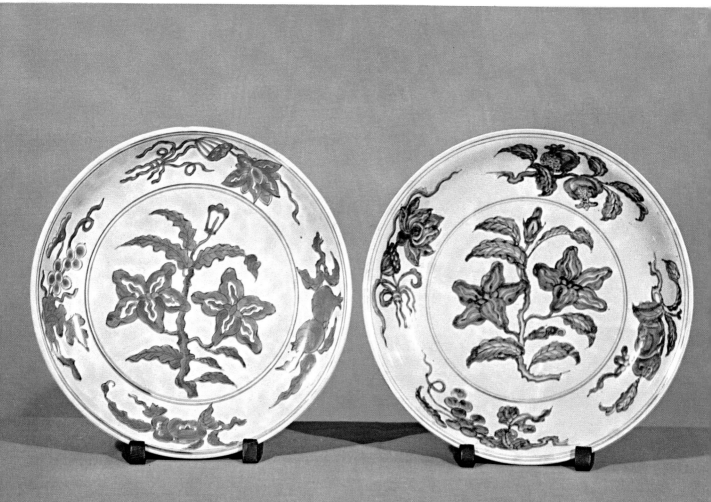

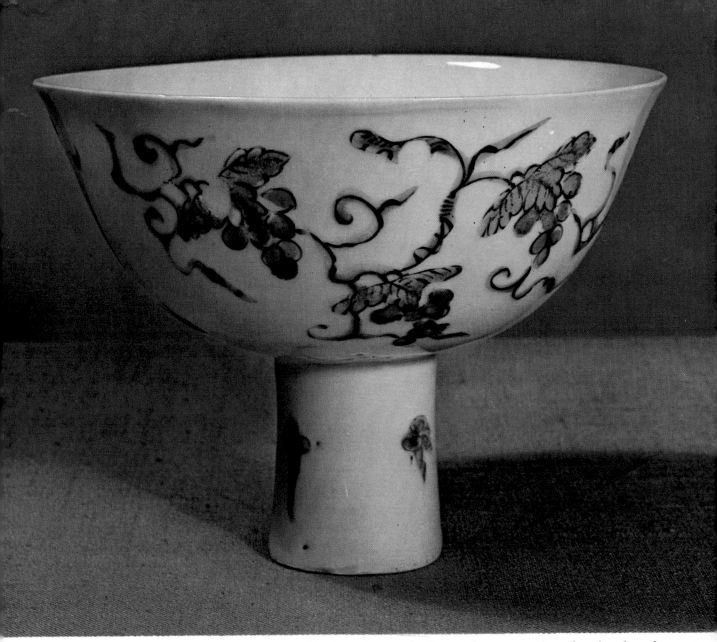

34　A Ming fifteenth-century stem cup painted
with green and aubergine grapes.

at this time. Among the Imperial wares are the palace bowls and
stem-cups painted with single garlands of flowering and fruiting
foliage. The bowl [figure 35] is accepted as a genuine example, as
is the stem cup [figure 36], once thought to be a seventeenth-
century copy. Also dating from this period are a series of pieces
painted with delightful winged elephants sporting amongst
clouds. The saucer dishes painted with flowering and fruiting
branches [figure 33] are also the subject of a certain amount of
controversy. They bear marks starting from Hsüan-te and con-
tinuing through to Ch'ieng-lung (1736–1796), and those
attributed to the early sixteenth-century emperors are often of
the period of their marks. The yellow ground on some of them

35 A fine specimen of a Ch'êng-hua palace bowl. The bold blue and white pattern of flowers frames a central chrysanthemum.

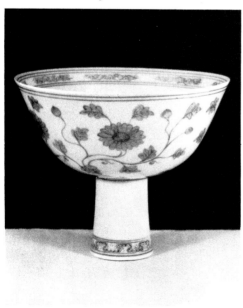

has been added in comparatively modern times. The brush-rest [figure 42] is another example of a genuine piece which is dated by most experts to the end of the fifteenth century. This shows the link between the early fifteenth-century style of figure painting with lightly delineated figures and the sixteenth-century style with elaborate shading of the robes.

Hsiao Tsung was the third son of Ch'êng-hua and succeeded his father at the age of eighteen in 1488 under the reign title of Hung-ch'ih. When the Lady Wen died in 1486 the Imperial kilns are said to have been closed down and the court was merely supplied by the private kilns still operating. With the exception of yellow-ground dishes of the type already mentioned, the only marked Hung-ch'ih blue and white pieces to have been identified are those painted with dragons, though again some of the unmarked pieces showing the transition of the fifteenth-century to the sixteenth-century style could belong to this period.

In 1506, after the death of his father, Wu-tsung became emperor under the name Chêng-tê at the age of fifteen. Like his grandfather, he was much under the influence of his eunuchs, many of whom were Muslims of Near Eastern origin. The Arab merchant, Ali Akbar, who visited China in 1505, returned to the Near East with the rumour that the emperor had been converted

36 A Ch'êng-hua blue and white stem cup.

37 A box with turquoise dragons overglaze on a blue ground. Ch'êng-hua period.

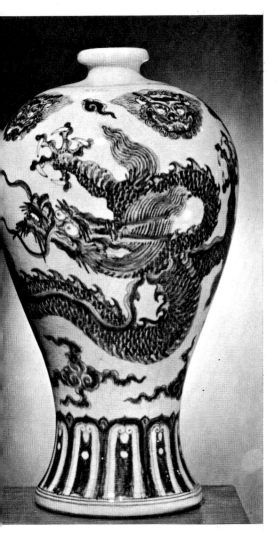

38 A very fine *mei-p'ing* with the Hsüan-tê mark. The Imperial five-claw dragon is particularly lively.

to the Muslim faith. Although this is certainly without foundation, the reign is remarkable for the number of pieces of Imperial quality decorated with Arabic inscriptions. A brush-rest in the David Foundation, of similar form to figure 42, is inscribed in Arabic 'pen-rest', and other pieces have longer inscriptions. The drawing is firm and the outlines are filled in with colour wash. As well as the Mohammedan wares there are dishes, bowls and vases with dragons amongst lotus foliage; though the design is over-crowded, the drawing is good.

Chêng-tê was succeeded in 1522 by his cousin, Shih-tsung, with the reign title Chia-ching. He was a man of strong character and dismissed all his cousin's corrupt eunuchs. He was also a fanatical believer in Taoism and in spite of the usual Chinese tolerance of various religious beliefs, issued an edict in 1535 that every image of Buddha in the Forbidden City should be destroyed. In spite of his firm character the reign was marked by rebellions and invasions by the Mongols on the one side and by the Japanese on the other.

The porcelain of this period is freely painted with bold outlines and strong washes, and is remarkable for the brilliance of the blue. The subjects are usually Taoist in origin and the Buddhist emblems disappear owing to the emperor's religious intolerance. The Immortals are depicted in landscapes, particularly Hsi Wang-mu, the queen of the Taoist Isles of the Blest. They are often with children. One also finds peach trees, emblematic of longevity, with their branches or trunks twisted into 'shou' characters ('shou' means longevity). Sages and children in landscapes are depicted as well as the 'Three Friends' (which are bamboo, pine and *Prunus*), deer, storks, dragons and fish. As it took some time to manufacture the fine cobalt and as much as three days to grind it, the cost of production was very high. Pilfering was very prolific and though various decrees were promulgated, corruption persisted on all levels. At the beginning of the reign there were eighteen Imperial kilns which were increased to sixty-two, although by the end of Chia-ching's reign they were again reduced to eighteen. At the height of this production as many as a hundred thousand pieces were made for the emperor in one year. Though the purplish-blue of this reign is considered the finest ever made, the body of the porcelain deteriorated because the local supply of china earth from the Ma An hills declined. It was at this time that the independent private kilns began to compete in quality with the Imperial wares, though much of the export ware was of poor quality and virtually indistinguishable from the later Wan-li pieces. By now they had begun to copy the finer pieces of the fifteenth century, the 'classic' wares of Yung-lo, Hsüan-tê and Ch'êng-hua, although they did not make exact replicas as they did in the eighteenth century.

40 *(opposite)* A bowl with white fish on a red monochrome ground. The reign-period mark is of Chêng-tê. Early sixteenth century.

In 1566 Chia-ching died, to be succeeded by Lung-ch'ing, his second son. He reigned only six years, and the porcelain of his period produced nothing new. What pieces have survived follow the characteristics of his predecessor and successor. The government of the land was left in the hands of his eunuchs, while the emperor dallied with his mistresses. The quantity of the porcelain required by the Imperial household was still very high, but the demand probably exceeded the supply, as the potteries had just been ruined by fire and flood.

Lung-ch'ing was succeeded by his son Wan-li in 1572. He was only ten when he came to the throne, and at first was advised by an excellent Prime Minister, but as he grew older, like so many of his predecessors, he allowed the government to fall into the hands of his eunuchs, while he himself indulged in licentiousness and vice. Wan-li's reign foreshadows the fall of the Ming dynasty. The Manchu were continually invading from the North. The Japanese under Hideyoshi invaded Korea, capturing Seoul and defeating a large Chinese army. For the first

39 A deep bowl of the Wan-li period decorated with dragons and flaming pearls in aubergine on a green ground.

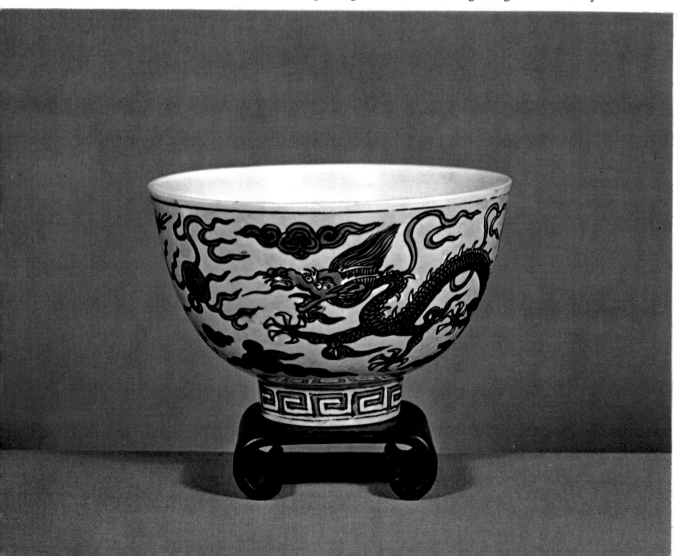

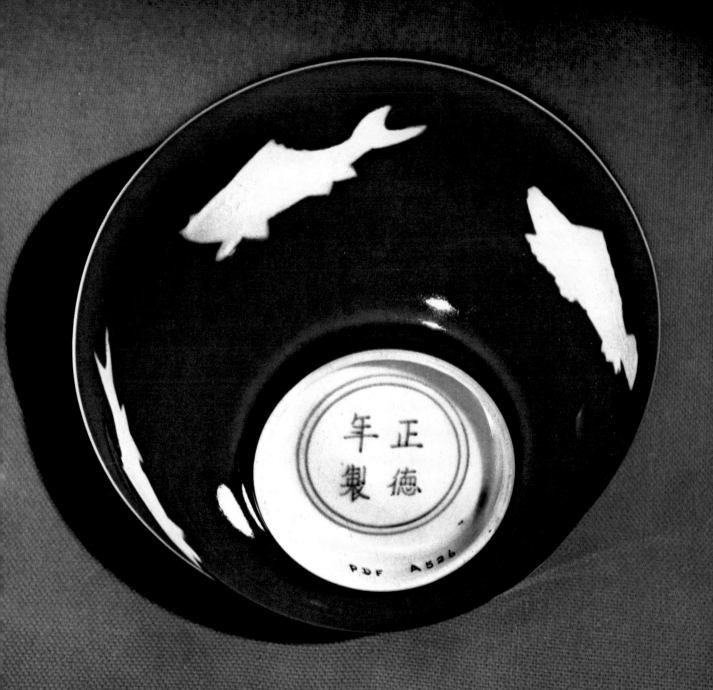

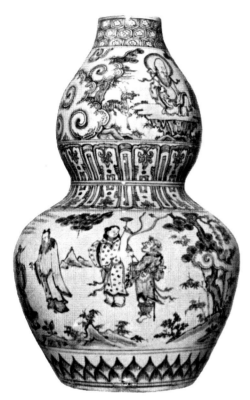

41 A sixteenth-century blue and white double-gourd vase, painted with Taoist Immortals.

42 Blue and white brush-rest, late fifteenth or early sixteenth century.

time Europeans started to reach China in large numbers. The Dutch took over from the Portuguese as the most powerful traders, and Matteo Ricci, an Italian Jesuit, lived in the country for nearly thirty years, from 1582 until 1610, trying to convert the Chinese to Christianity. Unfortunately his descriptions of the contemporary porcelain are rather meagre, beyond stating that the best *porsolana,* as the Portuguese called it, came from Kiangsi and was sent to all parts of China, as well as being exported to the neighbouring kingdoms, and even Europe. The china clay of the Ma An mountains, which had, as already mentioned, begun to give out during the reign of Chia-ching, was finally exhausted and it became necessary to transport it from the Wu Men T'o, which was twice as far from Ching-te-chên. The private kilns had to do their best with the inferior deposits from Po-yang Hsien. The imported Mohammedan blue also gave out during Wan li's reign, but by now they managed to purify the local cobalt sufficiently to produce a good colour, though paler than that made during the reign of Chia-ching. The imperial demands on the potters were as difficult as ever and they had to give many of the orders to the private kilns in order to keep up with the Imperial needs. One of the potters, a certain T'ung, was made so miserable by the excessive demands made on him to produce some large fish bowls for the palace, that he leapt into the kiln. The bone ash from his remains was just what was lacking in their constitution, and the bowls which previously would not come out of the kiln uncracked proved perfect. For his act of self-sacrifice, T'ung's fellow potters canonized him. The exactions of the Imperial orders became so severe that in 1583, Wang Ching-mu, a supervising censor, remonstrated with the emperor on his extravagance, and the orders for the less useful wares were cut by half. In spite of this, the potters were driven to rioting in 1598 and 1605.

For the first time quantities of porcelain began to appear in Europe, and one can still find quantities of Wan Li blue and white porcelain in a number of the older European country houses, especially in England where they have not been disturbed by war and revolution. These pieces are of coarse, greyish-blue, thinly potted paste, with sand often adhering to the foot rims. On the underside there are 'chatter' marks (light fluting in the paste as if cut by a knife). The designs are usually very crowded, the centres painted with ducks amongst lotus plants, birds on rocks, cicadas on leaves, the borders with elaborate arched panels, each with a flower or fruit spray. The commonest forms were dishes, plates and bowls, sometimes with fluted borders, while ewers known as 'Kendi', or 'Narghili' (incorrectly) became common. These often have compressed bodies in the form of elephants, frogs or other animals, and birds with little spouts and tall necks. The Delft potters seized upon

43 A Wan-li blue and white compressed oviform vase, painted with Imperial dragons chasing flaming pearls.

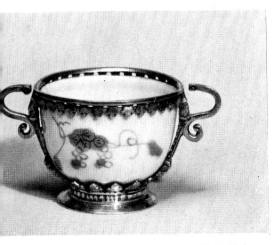

44 A Ming blue and white cup, with English sixteenth-century silver-gilt mounts.

these Wan-li plates and dishes when they arrived in Holland and copied them extensively. Almost the only porcelain that appears in Dutch still-life pictures of the seventeenth century are these pieces, and it is very hard to tell from the painting whether the original Chinese dish or the Delft copy is depicted. Many pieces which came to Europe were mounted in silver and more highly prized than they merited, since porcelain was still a novelty and the secret of true porcelain was not to be discovered for another hundred years, and only then after much experiment and many false trails.

After the death of Wan-li in 1620, the Ming dynasty began to break up. His eldest son T'ai-ch'ong died after a month, reputedly poisoned by the dowager empress. His son T'ien-chi succeeded him and reigned for seven years, dying at the age of twenty-two. His brother Ch'ung-cheng succeeded him in 1628 and reigned for seventeen years. He was the last of the Ming emperors. Though he was supposed to be a good man, he came to the throne too late and was struggling against impossible odds. In 1629 the Manchu reached the gates of Peking, but were repulsed, and in 1644 he hanged himself, as traitors were opening the gates of Peking to the enemy. Almost no Imperial porcelain was made during these last two reigns, and those pieces which bear the mark are mostly undistinguished, painted in a blackish blue with sketchy designs of Immortals or flowers. On the other hand, the private kilns, together with their artist potters, were producing fine pieces. Figure 46 is certainly of this period and is not only painted in a most beautiful blue, but the decoration and the calligraphy are delightful. It is very hard to date many of these pieces, and though they are traditionally called Ming, many of them belong to the beginning of the Ch'ing dynasty.

MING COLOURED WARES

Almost simultaneously with the discovery of painting in underglaze blue, the Chinese also found the secret of painting in underglaze copper-red, and there are a number of fine pieces dating from the end of the fourteenth century painted in this manner. The red proved much more difficult to control than the blue, and unless the temperature was absolutely constant it tended to become black through over-firing. The large dish [figure 50] is an example of this drawback, the colour having turned a deep reddish-brown with only one spot of true copper-red near the centre. The shape of this piece shows strong Mongol influence, being based on a Persian damascened metal original. The painting shows the peculiarities already seen on fourteenth-century blue and white. By the reign of Hsüan-tê and the middle of the fifteenth century, they had learnt to control it better and there are a number of pieces beautifully painted with dragons and flowers. As with the blue, they used the red as a mono-

45 The back of an early sixteenth-century saucer dish painted with Imperial dragon and phoenix in overglaze iron-red.

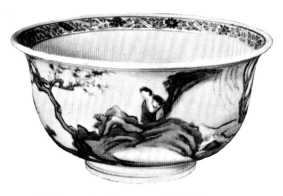

46 A seventeenth-century Ming blue and white bowl.

47 The interior of a Chinese merchant's shop with porcelain intended for the European market.

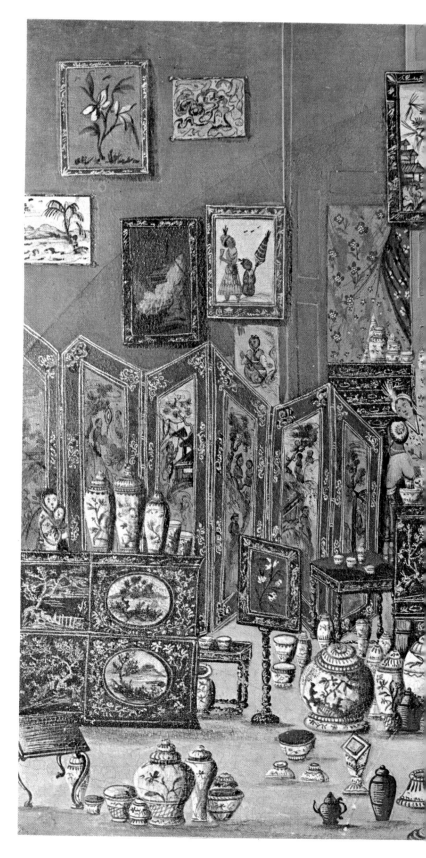

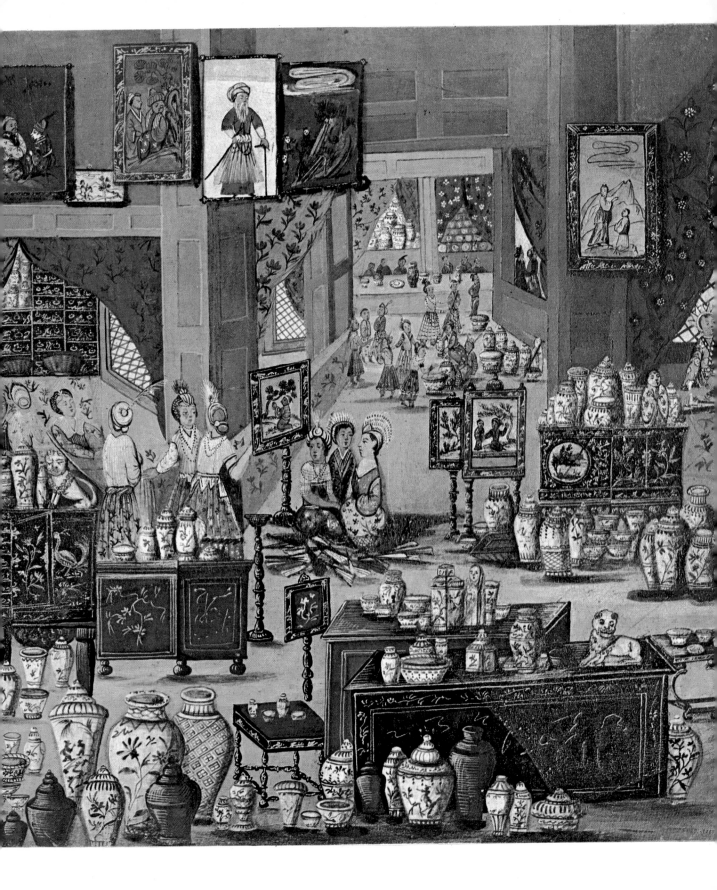

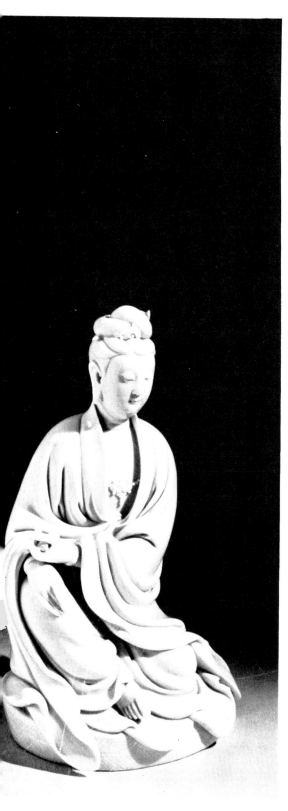

chrome; it is from this that they developed their famous *sang-de-boeuf* or ox-blood glaze. The bowl [figure 40] dating from the reign of Chêng-tê, with its white fish reserved on a red ground, is typical of the finest of the middle Ming productions. During the following reign of Chia-ching (1522–66), the potters are reputed to have lost the secret of making the copper-red glaze, and it was not rediscovered until the end of the seventeenth century. Already by the middle of the fifteenth century they had learnt to enamel in iron-red (a coral shade), which they found much more reliable. As time went on they used it more and more. The dish [figure 45] dates from the first half of the sixteenth century, and the mark shows that it was made for use in the Imperial kitchens. It is painted in iron-red and the mark explains the apparent contradiction of the poor quality of the porcelain (a coarse yellowish paste) together with the five-clawed dragon, at this date reserved for Imperial wares alone.

Though it was not as common as in the Sung dynasty, white porcelain was also made throughout the Ming dynasty, and some of the most beautiful pieces of the fifteenth century are undecorated. The jug illustrated in figure 55 is of this date, and owing to its peculiar shape is known as a 'monk's cap jug'. White bowls and stem cups bearing the mark of Yung-lo have hidden (an-hua) decoration. They are of very thin porcelain, and when held to the light, a design, normally of dragons chasing pearls, can be distinguished. This was effected by incising the design in the biscuit body of the piece before adding the colourless white glaze. The form of these white stem cups is very beautiful. Later in the Ming dynasty the Fukien potters with their centre at Tê-hua began making white porcelain with a peculiar and attractive creamy glaze. The most common pieces which have survived are figures of Buddha, Kuan-yin [figure 48] and the Lohans. After the arrival of the Jesuits, Kuan-yin, a reincarnation of Buddha, originally depicted as a rather effeminate youth and by the Ming dynasty as feminine in appearance, began more and more to resemble the European Virgin Mary. Small sacrificial cups were made in the form of tree stumps with *Prunus* blossom and sometimes animals and trees. These are mostly seventeenth- and early eighteenth-century and were copied by many of the early European factories. Bowls with incurving lips and lion's mask handles are also fairly common in the seventeenth century.

Monochromes were further developed during the Ming dynasty. Apart from the celadons, white and brown glazes found in the Sung and earlier dynasties, we find pieces entirely covered in cobalt-blue or copper-red glazes, sometimes with designs reserved [figure 49]. Yellow was the Imperial colour and reserved for the emperors' use, and most of the surviving pieces covered in a yellow glaze are saucer dishes and bowls, though vases and

48 A fine example of *blanc-de-chine* (tê-hua porcelain) – a seated Kuan-yin. Late Ming.

50 A Ming fourteenth-century large dish
decorated in underglaze red. The red has altered
in colour to a brownish shade due to imperfect
control of kiln temperature and other factors in
firing.

49 A fourteenth-century Ming mei-p'ing, with a
dragon reserved in white on a blue ground.

bottles were also made. This was probably begun during the Hsüan-tê reign, but most of the marked yellow pieces of this reign which are now in Europe appear to have been redecorated. The majority bear Hung-ch'ih, Chêng-tê or Chia-ching marks, though a few belong to the Ch'êng-hua period. More rarely on comes across green and turquoise monochromes, the former sometimes enriched with gilding. The iron-red enamel was also used in the latter part of the dynasty as a monochrome, its tomato or coral-red colour being particularly popular in Japan. The *Kinrande chawan* (brocade style tea bowls), with the ground colour enriched with gilding, mostly date from the Chia Ching period and occasionally have green, turquoise and blue grounds. Very few of these are found outside Japan and were not considered of great importance in China; they were most probably made for export. The Japanese have always valued them highly and consider some to be national treasures; as a result many extremely good copies of these have been made in Japan.

These colours were often used in combination. I have already referred to the dishes painted in blue with Imperial yellow grounds. The iron-red was also used with underglaze blue from the Ch'êng-hua period for stem cups, bowls, dishes and vases, often with amusing fabulous animals contrasted against blue waves. The green was particularly used in dishes, bowls and vases incised with dragons chasing pearls amongst cloud scrolls, the decoration enamelled on the biscuit in the green. Yellow is

43

52 *(opposite)* A pottery
ridge-tile in the form of a
pack-horse. Ming dynasty.

sometimes used as a ground colour in contrast to the green. A
fine circular box in the British Museum has turquoise dragons
on a deep blue ground. The bowl [figure 39] with aubergine
dragons on a green ground dates from the Wan-li period and
follows the same tradition.

There is no enamelled porcelain which can be ascribed to the
fourteenth century, but on the evidence of the famous Porcelain
Pagoda, built during the reign of Yung-lo at Nanking, it must
have been made at this time. This was unfortunately destroyed
by the rebels in 1856, but a Captain Cranville Lock gives us a full
description of it as he saw it in 1842: 'The porcelain is fastened
to the tower with mortar, as Dutch tiles are upon a stove, except
the projecting cornices and bas reliefs of grotesque monsters,
which are nailed. The various colours are white, yellow, red
and green.'

51 A late Ming polychrome
dish, Wan-li period.

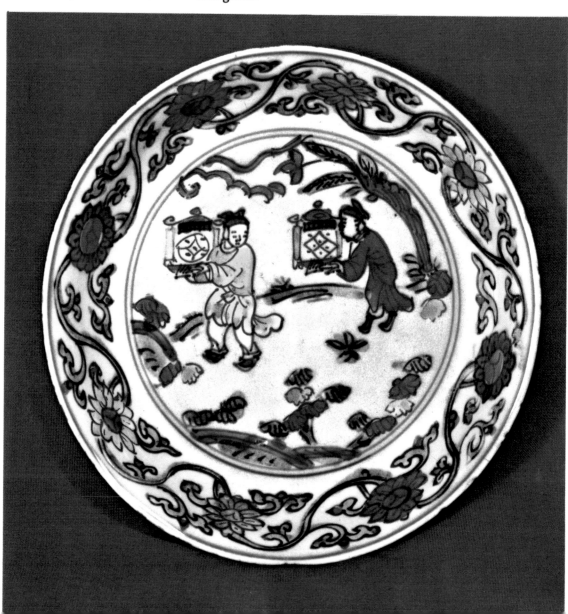

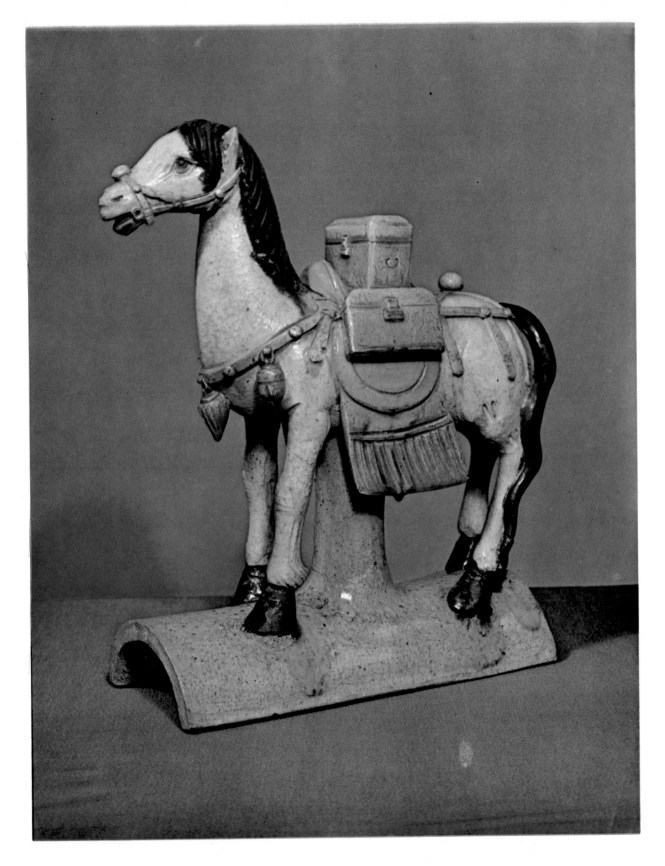

45

53 A blanc-de-chine sacrificial cup. Numerous examples reached Europe in the seventeenth century and were copied in many places there.

54 A Ming baluster vase decorated with lotus plants and kingfishers on a turquoise ground. Probably a provincial piece from the early sixteenth century.

55 A Ming white porcelain 'monk's cap' jug of the fifteenth century.

The Chinese believe that five-coloured wares with enamelled decoration date from the reign of Hsüan-tê, and there are two bowls, one in the David Foundation, which bear the cyclical date for 1433 and which are enamelled with *Prunus* sprays in turquoise, red, yellow-brown and green. These enamels are of a type one would expect from an early experiment, with strong drawing but thick and opaque enamels. There are other enamelled pieces bearing the Hsüan-tê mark, but these are possibly sixteenth-century. There are a quantity of enamelled pieces which are dated to the Ch'ëng-hua period, the most famous of

56 A late Ming dish made in south China. The The curious design in the centre is said to owe something to European engravings.

57 A Ch'êng-hua cup in *tou ts'ai* (contending colours) with decoration of chickens and plants. Such cups are often called 'chicken cups'.

58 A Ch'êng-hua stem cup with *tou ts'ai* decoration of stylized flowers.

which are *wu ts'ai* (five-colour) bowls and stem cups. The outlines of these are drawn and washed in blue and then enamelled over in red, green, yellow and purple. This sometimes gives a clobbered (redecorated) effect when the enamels have not fired well. The porcelain is very thin, fine and translucent and the mark thinly written. The most sought after are the stem cups decorated with vines and bunches of grapes, and then the cups decorated with chickens amongst flowering plants [figure 57]. These were all copied in the seventeenth century, and it is only with years of practice that one can tell the difference between the original and the copy. Also attributed to the Ch'êng-hua period are a series of very heavily potted, slender baluster vases, usually with their lips missing and made in four parts. They are almost certainly of provincial manufacture, and therefore probably slightly later, though none has yet been happily placed in the history of the development of the Ming porcelains. They usually have a turquoise ground and are decorated with kingfishers amongst lotus plants [figure 54] or with formal flowering foliage. Another provincial ware which probably started in the fourteenth century are the *san ts'ai* (three-colour) stonewares. They are almost certainly developed from the Tz'u-chou stonewares of the Sung dynasty. Typical of these is the beautiful wine jar, which has a brilliant turquoise ground and with the design in yellow and aubergine in relief and outlined in the clay. Some of these jars have pierced or reticulated outer skins with designs of figures or flowers in relief, and normally have purple or turquoise grounds. Tall vases with the handles in the form of flower sprays, as well as small bowls with incurving lips, are also found. The best of these pieces are magnificent in form and colour, and are made of a very strong stoneware, but later in the Ming dynasty the material became softer, and the colour and form is not so good. The factories which produced these fine vases also produced figures of Immortals and emperors [figure 61], which continue into the Ch'ing dynasty. They also probably made the tiles for the pagodas and temples with figures of animals, humans and demons. Like the less fine vases and figures, some of these are very difficult to date as the tradition was carried on in precisely the older formula until a comparatively recent date. Many authorities date them as 'Ming reign or later'.

After the Ch'êng-hua reign, enamelled wares no longer have to be reckoned by a handful of documented pieces. However, it is not until the reign of Chia-ching that they have survived in any quantities. The shapes now included square bulbous vases as well as some with trumpet-shaped necks and globular bodies. A favourite decoration of this period was the theme of boys playing, and Taoist Immortals on terraces and in landscapes, enamelled in red and turquoise [figure 63]. Some of the finest

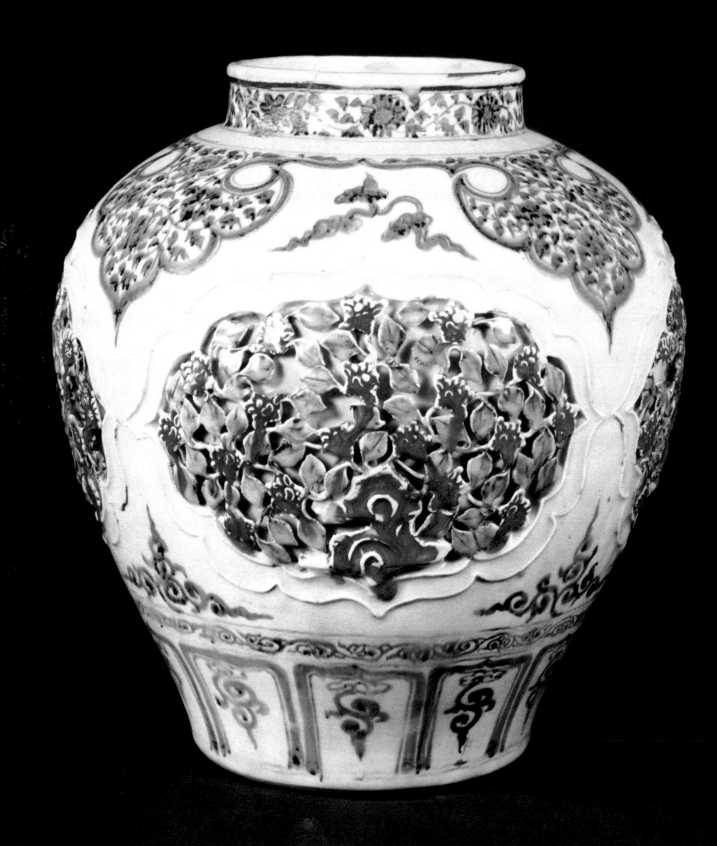

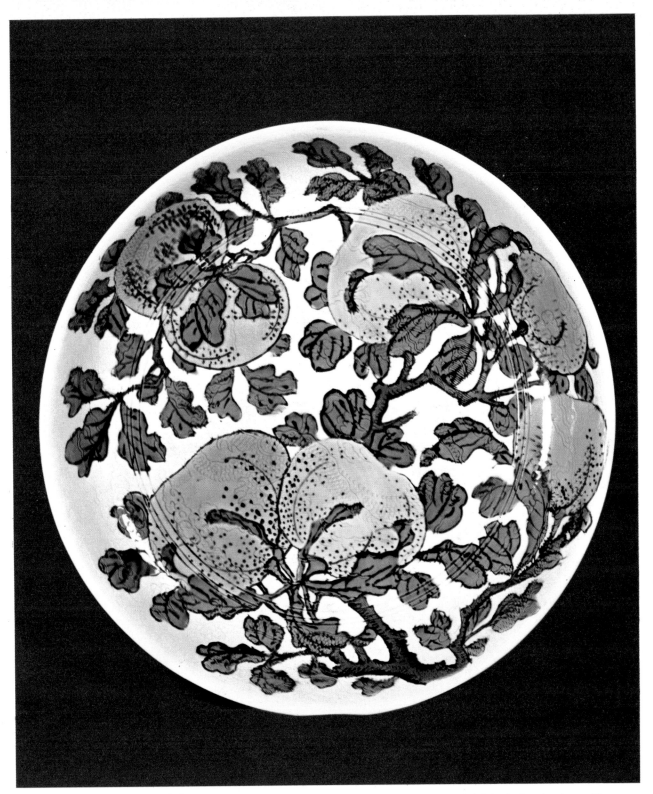

59 *(opposite)* Mid-fourteenth century underglaze red and blue Ming wine jar.

60 Imperial dish incised underglaze with dragons and enamelled with peaches on a branch. K'ang-hsi period.

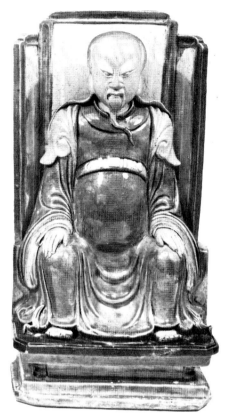

61 A Ming figure of an emperor seated on a throne, with biscuit porcelain head and glazed robes.

coloured wares of the Chia-ching period are a series of jars with yellow and iron-red fish amongst water weeds in underglaze blue and enamel colours. The bowl [figure 64] which is enamelled in turquoise and other colours with Buddhistic lions, cloud scrolls and branches on a yellow ground, has always been considered to be of this period and bears the mark of Chia-ching. However it bears many similarities to the transitional wares of the seventeenth century and is more probably of this later date. The coloured wares of the Wan-li period are on the whole less vital and rather more insensitive than those of Chia-ching. The paste becomes coarser and some of the shapes are clumsy, but many of the larger pieces are still effective owing to their massive forms. Figure 51 shows a dish which is typical of the better quality smaller pieces of this period. The *wu ts'ai* (five-colour) decoration of underglaze blue, red, yellow, green and aubergine, already fashionable in the reign of Chia-ching, continued through the seventeenth century in the transitional wares until the underglaze blue was replaced by the enamel blue of the *famille verte* during the reign of K'ang-hsi. The coloured wares of the early seventeenth century are somewhat difficult to date, as, owing to the troubled times, practically no Imperial porcelain was being made, and the work of the artist potters carries right through to the beginning of the reign of K'ang-hsi. A series of saucer dishes bearing the mark of T'ien-ch'i with blue and enamel Immortals were very popular in Japan, and were extensively copied in that country. Large potiches in *wu ts'ai*

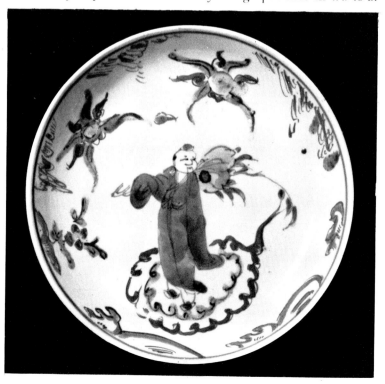

62 A Tien-ch'i saucer dish made for export to Japan. The figure is painted in blue and enamels.

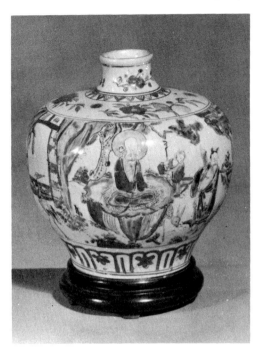

63 A Ming vase decorated in enamel with a portrait of the Taoist Immortal, Shou Lao; sixteenth century.

enamels were very popular during the transitional period, and were usually decorated with boys amongst flowering plants, Buddhist lions sporting with brocaded balls, boys at play, flowering and fruiting branches, and horses flying amongst aubergine waves.

Amongst the provincial wares not already mentioned are the 'Swatow' pieces which were probably made near Shih-ma in Fukien; the body of the pieces is coarse and greying with lumps of sand adhering to the underside. They are, however, freely painted in red, green and turquoise. The majority of the celadons were made at various kilns in the Ch'u Chou prefecture in Southern Chekiang. They mostly consist of dishes and bulb pots incised or moulded under the glaze with scrolls and flower sprays. They are very strong, and many pieces have survived. There is an immense collection of these Ming celadons in the Topkapu Sarayi in Istanbul. Polished red stoneware was made at Yi-hsing near Shanghai. Tea pots were the most common pieces made here, and the colour varied from pale buff to a deep brown, the most common being the reddish brown copied by Böttger at Meissen and in Staffordshire in the eighteenth century. The form of some of these is very beautiful. Another well-known provincial ware was made at Kwangtung near Canton, which had a dark brown stoneware body covered in blue, green, red, white and yellow glazes, often *flambé* or mottled and full of bubbles. The glaze resembles that of the Chün wares of the Sung dynasty.

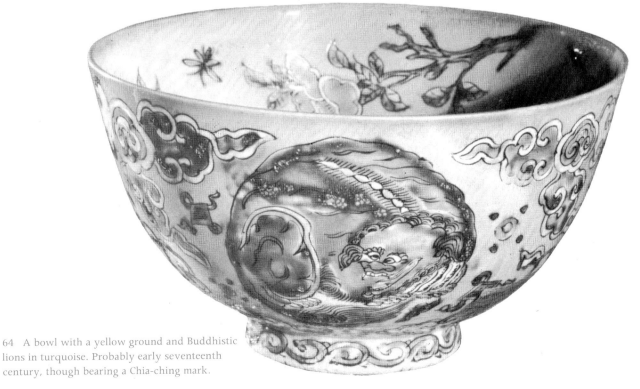

64 A bowl with a yellow ground and Buddhistic lions in turquoise. Probably early seventeenth century, though bearing a Chia-ching mark.

65 A *famille verte* cockerel of a very uncommon type.

The Ch'ing Dynasty (1644–1912)

66 A *famille verte* ewer modelled as a hen.

67 A *famille verte* dish modelled as a leaf.

CH'ING WAS THE CHINESE NAME taken by the Manchu (Tartar) conquerors who, although always harrying the borders of the Chinese empire, did not meet with great success until after the death of the emperor Wan-li. They gradually obtained a firmer hold on the country until, after the suicide of the last Ming emperor, Ch'ung-chêng, in 1643, the first of the Manchu ascended the throne under the title Shun-chih. Like the first Ming emperor, the greater part of his reign was spent in putting down rebellions. During one of these, that of Wu San-kuei from 1673 to 1675, Ch'ing-tê-chên itself was sacked and burnt. It was not until 1683, the twenty-second year of the second Ch'ing emperor, K'ang-hsi, that Ts'ang Ying-hsüan was appointed director of the newly rebuilt Imperial factory and that the fine Imperial wares of the Ching dynasty began to appear.

Although no porcelain of Imperial quality was made during the reign of Shun-chih (1644–1661) or during the first twenty years of the reign of the emperor K'ang-hsi, the independent artist potters at Ching-tê-chên had been carrying on the traditions of the final phase of the Ming dynasty. It is in fact very difficult to distinguish those pieces made during the third quarter of the seventeenth century from those which belonged to the period of the last Ming emperors. The few pieces which are indentifiable from cyclical dates of the period, or with the Shun-chih mark, are of good transitional quality comparable to figure 46. Imperial patronage, however, did continue to a slight extent. In 1654 there was an Imperial decree ordering dragon bowls for the palace gardens. Unfortunately, these were never made, owing to difficulties of manufacture. In our studies of the porcelain of the K'ang-hsi period (1662–1722) the letters of the Jesuit Father d'Entrecolles, who wrote to Father Orry in Paris from Ching-tê-chên in 1712 and 1722, are of great help. He gives a full description of the town as well as the organization of the factory and the method of making the china. As mentioned previously, the two ingredients are kaolin clay and the *pai-tun-tzu* (called by d'Entrecolles, 'petuntse'). The kaolin was mixed with lime and bracken ashes to form the glaze and the petuntse was crushed into small white bricks. The organization of the decorators was one of the earliest examples of mass production, and like the other workmen their condition was very poor. D'Entrecolles states, 'The painting is distributed in the same

53

治年製 大清順	熙年製 大清康	正年製 大清雍	隆年製 大清乾	年製 嘉慶	光年製 大清道

Shun-chih
(1644-1661)

K'ang-hsi
(1662-1722)

Yung-chêng
(1723-1735)

Ch'ien-lung
(1736-1795)

Chia-ch'ing
(1796-1820)

Tao-kuang
(1821-1850)

Ch'ing Dynasty Reign-Period Marks

workshop among a great number of workmen. One man does nothing but draw the first colour line beneath the rims of the pieces, another traces flowers, while a third paints; this man is painting water or mountains and that one either birds or other animals. Human figures are generally given to the least skilled.' D'Entrecolles describes everything minutely, sketching the interior of a kiln and noting the amount of fuel used ('Some one hundred and eighty loads of pine fuel'), and the result: 'often everything is lost, and on opening it (the furnace), the porcelain and the cases will be found to be converted into a solid mass, as hard as rock.'

68 A pair of *famille verte* candlesticks enamelled on the biscuit.

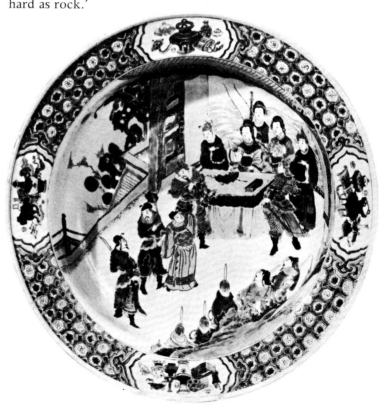

69 An audience scene painted on a *famille verte* dish.

54

豐年製 大清咸

治年製 大清同

緒年製 大清光

年製 宣統

年製 洪憲

Hsien-fêng (1851-1861)　　T'ung-chih (1862-1873)　　Kuang-hsü (1874-1907)　　Hsüan-t'ung (1908-1912)　　Hung-hsien (name adopted by Yuan Shih-k'ai in 1916)

Of the pieces which have reached Europe by far the greatest number are the products of the private kilns of Ching-tê-chên. Though the paste and decoration varied considerably, the majority of the plates, dishes, bowls and vases have certain common characteristics. The glaze is bluish in tone without any of the orange-skin appearance seen both on Ming and early nineteenth-century porcelain. There are often small imperfections in the form of irregular small black spots. The larger pieces sometimes have frit marks round the rim where the glaze has been chipped away. These are almost never found on imitations. The unglazed foot rims are sometimes burnt a pale

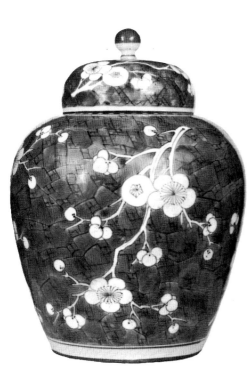

70 A blue and white Hawthorn ginger jar, of a type for which $15,000 was paid before the First World War.

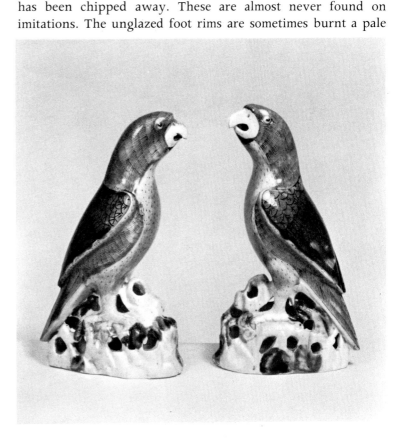

71 A pair of *famille verte* parrots of a type which was very popular in Europe.

55

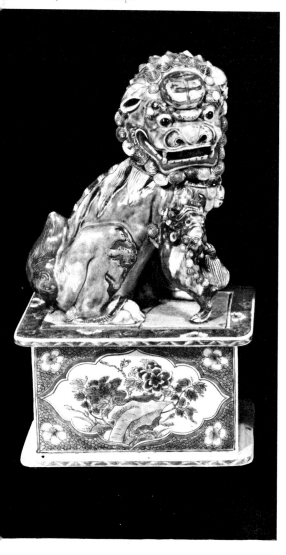

72 *(below and opposite)* A pair of *famille verte* Buddhistic lions enamelled on the biscuit. Quantities of these figures were exported to Europe.

73 A K'ang-hsi *famille verte* large bottle, painted with Buddhistic lions at play.

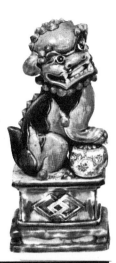

74 A Buddhistic lion,
with a turquoise and
purple glaze.

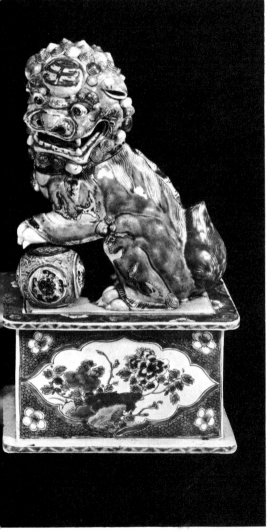

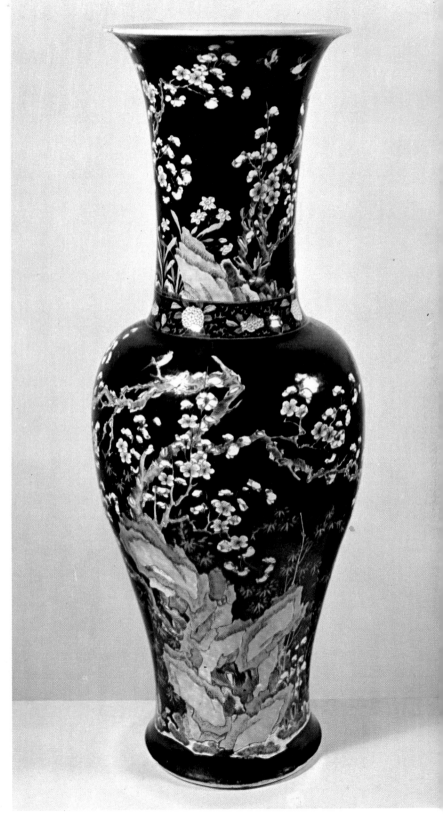

75 A K'ang-hsi *famille noire* baluster vase.

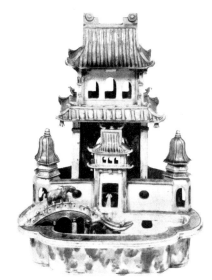

76 Model of a pagoda in *famille verte*.

77 An early eighteenth-century figure of a stag.

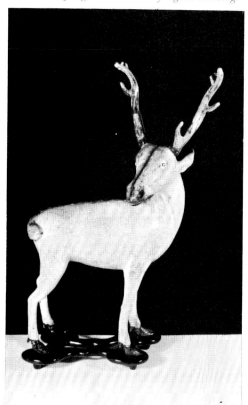

orange buff. The paste is thin, grey-white except on the best quality pieces and very strong. It is more easily subject to hair cracks than to deep chips. The *famille verte* enamels common to this period are two shades of green, whence comes the name, iron-red, yellow and aubergine. In the early part of the reign these were often used in combination with the underglaze blue, but later enamel blue was substituted and more commonly used. The decoration continued the traditional Chinese ideas, though sometimes with greater elaboration. Scenes with numerous people on terraces with buildings overlooking lakes, usually illustrating a romance or fable [figure 56], birds, flowering plants issuing from rockwork, Buddhistic lions playing, dragons, Taoist, Buddhistic and formal subjects all played their part. Elaborate designs round the borders also come in at this time, although these were intended more for the European market than for the Chinese. Vases and teapots of hexagonal, octagonal and quatrefoil form appear at this time, and the grounds round the panels are often decorated with *ju-i* lappets enriched with flowers, trellis, cell and diaper work, mixed with fret patterns, shagreen ornament, seeded panels and plain colour wash. Of the last named there are two well-known sub-sections of the *famille verte*, known as *famille jaune* and *famille noire*, the yellow and black families. These were very popular with our ancestors between about 1870 and the start of the Great War, the finest collection being that formed by the late George Salting and bequeathed to the Victoria and Albert Museum in 1910 [figure 75]. Such pieces, being sold in America for the equivalent of as much as 20,000 golden sovereigns, were naturally prey to the forger. There are in fact some modern experts who say that almost all the large vases with black grounds are not genuine, though this is hard to believe. There is no doubt that black enamel was used on *famille verte* pieces and there has never been any question regarding the authenticity of pieces like the tea pot illustrated in figure 80. On the other hand, many *famille noire* vases are obvious imitations with stiff drawing, weak shapes and a grey body with an iridescent sheen even where there is no black glaze. There are often vases where the porcelain is quite genuine but from which some unimportant decoration has been ground off and covered over by the thick opaque black enamel. Some of these are betrayed either by the ghost of the original decoration showing through or, as in an example of a vase which I saw recently, by a hair crack, but with the enamel covering the crack having been added after the damage had occurred. Pieces with yellow, green and coral grounds have not been tampered with so often, principally because the black ground, being opaque, would hide any evidence of earlier decoration.

Many of the *famille verte* porcelains are enamelled directly on the biscuit and not on top of a fired white glaze as is the normal

80 A *famille noire* hexagonal tea pot.

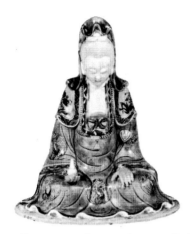

78 *Famille verte* seated Kuan-yin, enamelled on the biscuit.

79 A *famille verte* figure of a man leading a pack-horse.

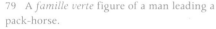

practice. This gives a totally different effect and is used in applying washes of green, yellow and aubergine. The majority of figures of this period are decorated in this manner [figures 67 and 68]. Amongst the most successful of the birds are the parrots [figure 71] which have unfortunately been so frequently copied in recent years, though the cock [figure 65] is a most unusual example. Figures of horses with attendant figures or riders are very popular and rare [figure 79]. Exported to Europe at the end of the seventeenth century as well as kept for Chinese collections are grottos and models of pagodas [figure 76], figures of Kuan-yin and other Immortals [figure 78], and boys [figure 68], while the most common of all are the pairs of figures of Buddhistic lions, forming spill holders, one playing with a cub and the other with a brocaded ball [figures 72 and 74]. These have been erroneously called 'kylins' or 'Ch'i-lin' for many years, but the kylin is a mythical animal with the head of a dragon, the body of a lion and the feet of a deer. Other types of porcelain enamelled on the biscuit are found in the sweetmeat dishes of different shapes, but fitting together on a tray. These are decorated with a variety of subjects, more often with lions, dragons and flowering plants, or simply with splashes of colours, the so-called egg and spinach design. Shallow conical bowls covered in plain glazes but with incised and decorated single sprays of foliage or fungus plants also occur. These are called Brinjal bowls, from the Anglo-Indian word for the aubergine which lends its name to the purple glaze with which they are so often covered.

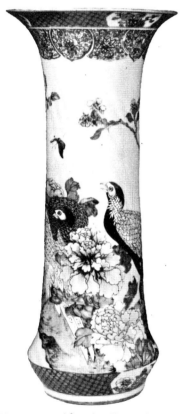

82 A K'ang-hsi peach-bloom vase, called by the Chinese kidney-bean red.

81 A Yung-chêng *famille rose* beaker-vase of the finest quality, painted with silver pheasants.

83 A K'ang-hsi
famille verte screen
decorated with a
lively design of
flowers and foliage.

84 An eighteenth-century celadon vase mounted with Louis XVI ormolu to form a ewer.

85 A detail of an enamel-painted vase, Ch'ien-lung period.

The blue and white of this period was the finest in technical achievement that the Chinese ever made. Both the quality of the paste and glaze was very good, the former of pure white texture, the latter with an even, blue-white sheen, but the excellence of the blue was the greatest achievement of the K'ang-hsi potters. In the best pieces one finds a translucent but brilliant cobalt without dark spots or blurred lines. Up to the Great War this also was very popular and as much as $15,000 was paid at Christies for a 'Hawthorn ginger jar' at this time [figure 70]. A similar piece was sold in New York recently for about $600. The decoration on these pieces is a design of flowering *Prunus* branches reserved on a blue cracked-ice-pattern ground. Owing to its popularity at the beginning of the century it was copied so profusely and so well that the West became flooded with these ginger jars as well as other pieces of blue and white, copying the seventeenth-century styles, with the result that collectors turned their eyes to other things. Another reason for the decline in favour of these wares is that they are somewhat cold and monotonous in modern interiors and do not mix well with coloured porcelains. However, the finest of the K'ang-hsi blue and white porcelain have come back into popular favour. Already those pieces imitating Ming styles have increased considerably, but the former, of which many large old country houses are still full, can be bought even from an important dealer for comparatively little. The shapes, forms and decoration follow those of the coloured porcelains, while for the greater part of the reign there was no distinction made between the Imperial and non-Imperial pieces. At the beginning of the eighteenth century, but still during the life-time of the emperor K'ang-hsi, pieces of a definite Imperial nature began to be made once more, and there was an increase in deliberate copies of Ming pieces. It was at this time that blue and white began to fall out of favour· in European eyes for decorative pieces, and the only pieces to be exported in large numbers were the services of so-called Nanking porcelain, named after the port from which they were shipped. However, there are some very fine Imperial quality pieces of blue and white dating from the reigns of the emperors Yung-chêng (1723–1735) and Ch'ien-lung (1736–1795), almost always copying fifteenth-century originals, sometimes bearing their correct marks and sometimes those of the pieces they resemble. It is usually fairly easy to distinguish the eighteenth-century copies, since the black spotting has been put on deliberately instead of appearing·accidentally, the paste has a somewhat more marked orange-peel texture and the drawing is not so free. There are, however, very few pieces about which there are differences of opinion, and these are not likely to come the way of the average collector. Towards the end of the reign of Ch'ien-lung the quality of the blue and white de-

89 *(right)* *Famille verte* plate, one of a set made for the sixtieth birthday of K'ang-hsi.

86 An eggshell plate of the Yung-chêng period with a 'ruby back'.

teriorated and did not revive until the end of the nineteenth century when potters began to fake K'ang-hsi pieces. No blue and white worth mentioning with original and artistic designs was produced during the nineteenth century.

During the reign of K'ang-hsi very few of the pieces bear the reign mark; this was partly due to an edict of Ch'ang Ch'i-ching, the superintendent of the Imperial factories between 1677 and 1680. This edict forbade the potters to use the *nien-hao* (reign

87 A Yung-chêng eggshell plate painted in the Chinese taste.

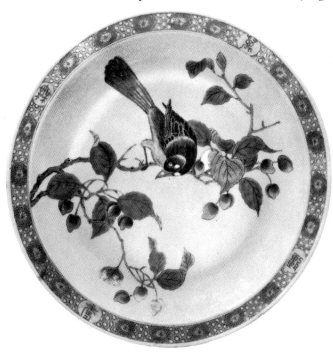

88 *(right)* A *famille verte* plate, painted with birds and flowering plants.

mark) of the emperor on their wares. It is impossible to tell how effective this order was, but the number of pieces either without a mark or merely with an artemisia leaf, a lotus blossom, an endless knot, an incense burner or other symbols within a double circle, suggests that it was obeyed. There are also a great number of pieces including some *famille noire* vases which bear the marks of Ming emperors, such as Ch'êng-hua and Hsüan-tê. It is obvious that these pieces could not have been made before the second half of the seventeenth century, and the only explanation why they were thus marked is that the pieces were so fine that they were considered as good as Ch'êng-hua or Hsüan-tê pieces. The quantity of blue and white pieces which bear rather roughly drawn K'ang-hsi marks are almost all fairly modern fakes.

90 A Ch'ien-lung lavender-blue vase.

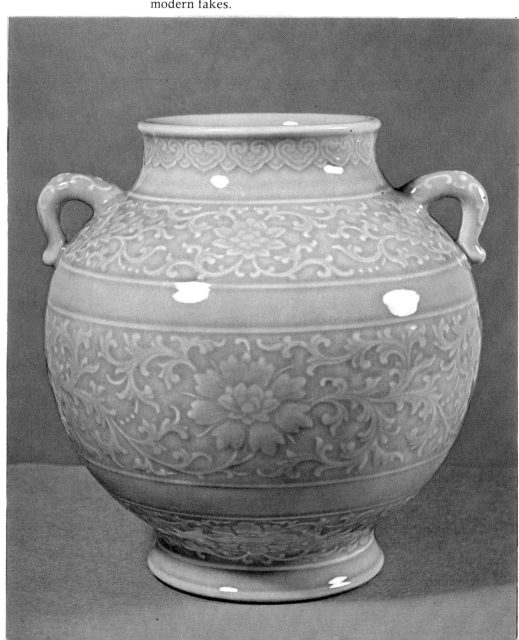

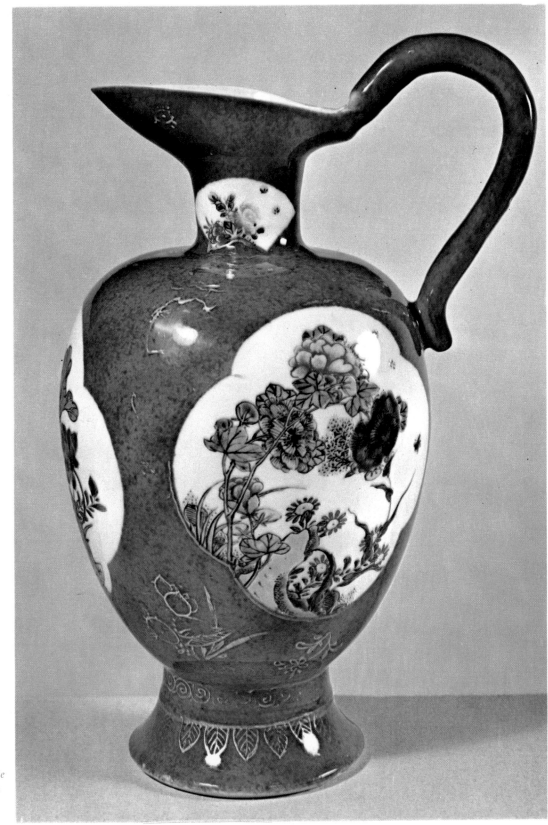

91 A K'ang-hsi
ewer with *famille
verte* panels on a
powder-blue
ground.

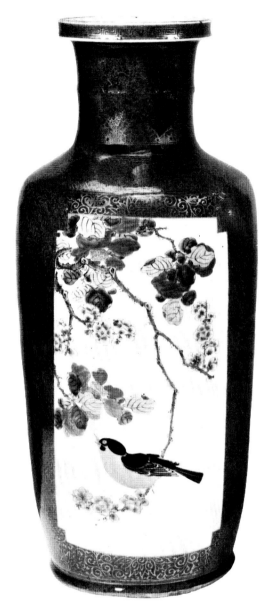

After the *famille verte* and blue and white, the monochrome wares of the K'ang-hsi reign are probably the most famous, the Lang Yao or ox-blood red being the most common. During the reign of Shun-chih, Lang T'ing Tso was appointed Governor of Kiangnan and his name has been traditionally associated with this red glaze; there is no documentary evidence of this and there are other possible explanations, one being associated by the Chinese author Kuo Pao-ch'ang with Lang T'ing-chi who was appointed Governor of Kiangsi in 1705 and was reported to have operated his own factory for the manufacture of porcelain. A third suggestion is that it belonged to the Chinese name for the Jesuit priest Castiglione, who might have painted the vase of which a detail a seen in figure 85, and who is certainly known to have decorated porcelain. It is possibly he who helped to introduce to China the famous *famille rose* enamel. This was discovered by Andreas Cassius of Leyden in about 1650 and is derived from gold chloride and iron. It was first used industrially in about 1680 by Johann Kunckel in manufacturing his famous ruby glass. A fourth possibility is simpler and could even be the real answer. Lang is a common Chinese surname and members of this clan are reputed to have lived near Ching-tê-chên. Some of them as a result must have worked at the potteries and one could have given his name to the discovery.

The Lang Yao or *sang-de-boeuf* glaze was first discovered during the Ming dynasty but lost during the reign of Chia-ching. The colour varies considerably from cherry red to a dull maroon and is often *flambé* with purple splashes, the glaze is sometimes slightly crackled and the lips are usually paler, sometimes an almost celadon colour. During the eighteenth century these pieces became rougher and the potters lost the secret of controlling the glaze which ran down over the foot and had to be ground off. The finest of these red glazes is the peach-bloom or bean-red. This is most commonly found on slender vases such as that illustrated in figure 82, and on water pots of beehive form, often incised under the glaze with circular dragon medallions. These normally bear the *nien-hao* of the emperor, K'ang-hsi, but have also been extensively copied in recent years. This glaze is extremely difficult to control, and many of the copies

92 *(above and opposite)* A pair of *famille verte* vases with powder-blue grounds.

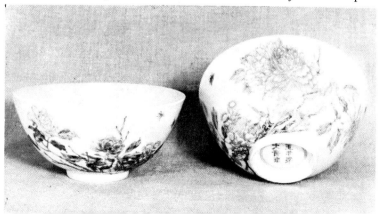

93 A pair of small bowls in the Chinese taste.
66 Yung-chêng *famille rose.*

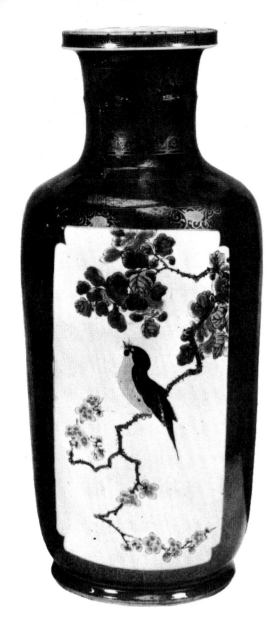

are betrayed by the very large expanses with green spots. The K'ang-hsi potters, having relearnt the use of the underglaze copper-red which had been replaced at the end of the fifteenth century with the overglaze iron-red, this being much more easily controlled in the kiln, began to use it quite considerably for the Chinese market. It was apparently not very popular in Europe and very little appears in old European collections. When it was used by itself it was almost entirely for copies of Ming originals, but when combined with blue was used on a variety of types including the snuff bottles which were made in such quantities later in the eighteenth and nineteenth centuries. It is also found during the Ch'ien-lung period combined with blue reserved in panels on a celadon ground. The other monochromes which came into fashion during the latter part of the seventeenth century are the apple green, of pale translucent colour with a crackle glaze, and the leaf or snake-skin green [figure 96], which was also used in combination with the Imperial yellow. The dish illustrated also has the green glaze on the reverse which is incised with dragons chasing pearls, and the centre of the base has the Yung-chêng six-character mark within a double circle.

Popular amongst the export wares was the powder blue; this often had panels reserved in *famille verte* [figures 91 and 92]. The black glaze was also introduced at this time and a little later a deep blue, incorrectly called Mazarin blue. Very popular during the Yung-chêng reign was the pale lavender colour called by the French *clair-de-lune* [figure 90], and at the same time a lemon yellow and a pale pink resembling strawberry blancmange were introduced, as well as the deep pink or ruby colour used so often on the reverse of the *famille rose* eggshell plate [figure 86]. They also continued to produce the celadon wares which have never been out of fashion since the proto-porcelains of the second and third centuries. Like the powder blue which was usually enriched with gilding, a brown glaze derived from iron was used in conjunction with the *famille verte*; at first it was of a pale coffee colour, called *café-au-lait*; later, in conjunction with underglaze blue and *famille rose* panels, it became a darker dead-leaf colour, known to the East India Company traders as 'Batavian ware'. Carried on from the Ming dynasty was the

94 A Ch'ien-lung bowl decorated with peaches in the Chinese taste.

turquoise glaze which, together with the celadon and *clair-de-lune*, was very popular with the French in the eighteenth and nineteenth centuries for mounting in ormolu [figure 84]. During the eighteenth century the potters experimented with these glazes to produce almost every conceivable variety of tone and colour, some with brilliant *flambé* glazes, others imitating a robin's egg, while yet others imitated bronzes, agates and other materials. Although wonders of the potter's craft, these imitations are not true to their medium and as a rule lack any real character. There were also copies of the Sung white (Ting) glazes and the *ko* crackle glazes, often with grey grounds.

As mentioned earlier, many of these new colours were produced under the directorship of Ts'ang Ying-hsüan, who was in charge of the Imperial factory between 1683 and 1726, although he had probably left some time before the latter year. The T'ao hu mentioned the invention of four colours, the eel-skin

95 A Yung-chêng bowl with decoration in green with iron-red bats, on a yellow ground

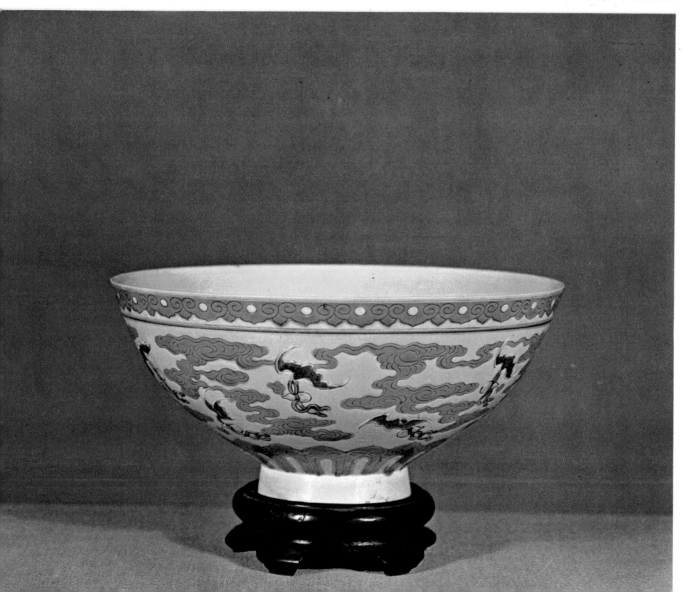

96 A saucer dish covered in a bright green glaze, and bearing the Yung-chêng six-character mark.

yellow, the spotted yellow (possibly the egg and spinach design already described), the snake-skin green [figure 96] and the turquoise blue which, though more refined and deeper than the Ming turquoise, does not appear to be very different in colour.

In the Hizen province of Japan they developed a combination of iron-red, underglaze blue and gold which became very popular in Europe and was commonly known as Imari porcelain. This was extensively copied in China, mostly for export, and many of the pieces of this type are of Chinese, not Japanese origin; the large vases with this red, blue and gold decoration, however, are usually Japanese and date from the late seventeenth and eighteenth and sometimes even the nineteenth century.

The *famille verte* porcelain of the Imperial kilns was usually decorated in simpler taste. Figure 89 shows an example that could have been made either for Chinese or European use, while

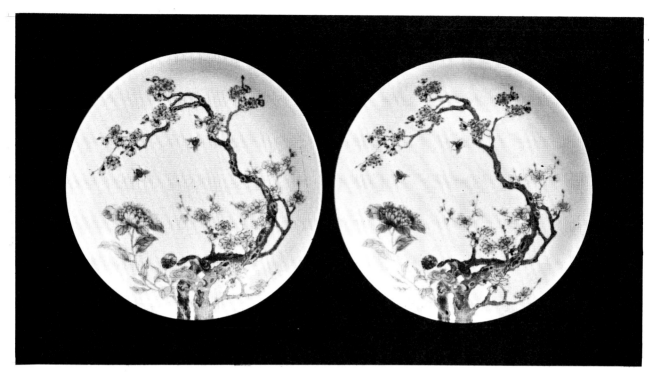

97 A pair of saucer dishes in the Chinese taste with Yung-chêng marks but actually made in the nineteenth century.

that in figure 88 is certainly a product of the Imperial factory and is reputed to be one of a set made for the emperor K'ang-hsi's sixtieth birthday in 1713 (the characters round the border read 'a myriad longevities without ending').

In 1722 K'ang-hsi died and was succeeded by his grandson Yung-chêng who, four years later, appointed Nien Hsi-yao as superintendent of the Imperial factory. Though the foreign pink occasionally appears in combination with the *famille verte* in pieces that probably date from before 1720, it is unlikely that any ordinary *famille rose* decoration was used before the appointment of Nien Hsi-yao, and it is to his directorship that one can attribute the fine vases, bowls and saucer dishes delicately and asymmetrically painted with single flowering branches running from the outside to the inside and sometimes with birds perched on them or flying off. The pilgrim bottle [figure 114] in the Percival David Foundation is a splendid example of this type of decoration, while the bowls in figures 93 and 95 show variations on this theme. The pair of saucer dishes in figure 97, though they bear the same six-character mark of Yung-chêng as seen on figure 93, date in fact from the end of the nineteenth century; the drawing is slightly stiffer and the glaze has an orange-peel effect not so apparent in the originals. At this date the very thin eggshell porcelain came into fashion and was also very popular in Europe. At first these were probably decorated at Ching-tê-chên [figure 87], but later many of the dishes and plates with ruby backs and elaborate trellis and diaper-pattern borders [figures 86 and 119] were decorated at

Canton. Eggshell vases were also made for the European market, sometimes delicately painted with Chinese figures and sometimes covered in pink or other monochrome glazes. The larger pieces, however, had to be of a stouter body, such as the beaker [figure 81], originally part of a five-piece *garniture de cheminée*, exquisitely painted with silver pheasants amongst peonies. The newly discovered pink enamel was also popular and the *garniture de cheminée* [figure 100], enamelled with cocks on rockwork has a deep ruby ground; this proved popular in Europe for a considerable time and figure 99 shows a plate with the same decoration made in Paris in the nineteenth century so expertly that it had been passed as 'Chinese, eighteenth century, but not of the finest quality' by several good judges of Chinese porcelain.

Nien Hsi-yao's directorship (1726–36) coincides almost exactly with the reign of Yung-chêng who died in 1735, and the Imperial wares of this period can all be assigned to his directorship. For the first time the porcelain appears to have considerable foreign influence, and Nien Hsi-yao wrote a book on foreign perspective, where he proclaimed himself to be a pupil of Castiglione, the Jesuit priest who is known to have decorated china as well as painted pictures. The Imperial kilns, unlike those producing export wares, were still used greatly for making copies of the Sung and Ming. The *Kuan*, Ju and *Ko* wares were very close copies and there is a bottle in the Percival David Foundation which even the Chinese Palace authorities accepted as genuine until a Yung-chêng seal mark was found concealed under the glaze. Both the underglaze copper-red and

98 A pair of bowls with bats in underglaze red on celadon grounds. Yung-chêng six-character marks.

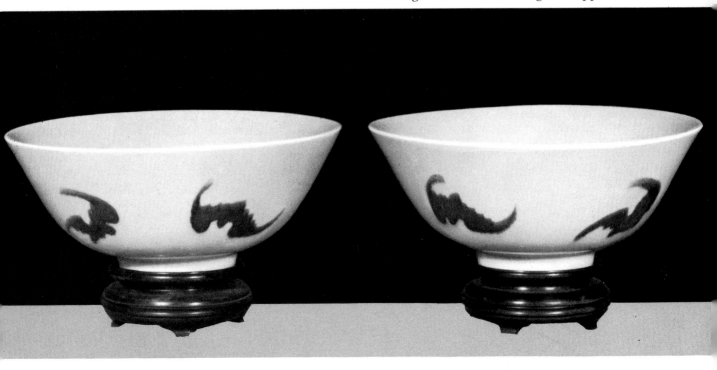

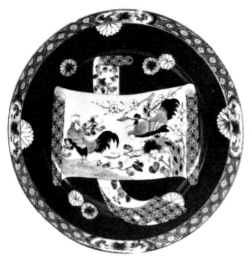

99 A French nineteenth-century fake of an eighteenth-century Chinese ruby-ground plate.

Mohammedan blue of the Hsüan-tê period were copied as well as the yellow dishes, bowls and vases reserved with blue flowers [figure 33]. The chicken and grape cups of the Ch'êng-hua period were also copied. Nien Hsi-yao also continued making the monochromes in the style of his predecessor under K'ang-hsi; his directorship is justly famous for his monochromes, and the *clair-de-lune* already mentioned [figure 90] was first made by him. Figure 98 shows a pair of bowls painted in underglaze copper-red with bats on a celadon ground, another type of decoration which was not done before. The yellow-ground bowls decorated in green with dragons and children at play were also made to Imperial order. The colour-plate [figure 95] shows a bowl with a slight variation on this theme with red bats holding double gourds amongst green clouds on the Imperial yellow ground.

Ch'ien-lung, who succeeded his grandfather in 1736, is perhaps, in European eyes, the most famous of Chinese emperors. He reigned for sixty years and abdicated at the age of eighty-five in 1795. Not only was he a great patron of all the arts but also a very fine administrator. For about the first fifteen years of his reign he had T'ang Ying as director of the Imperial factory. He was a most conscientious administrator and has left us much in writing concerning his efforts. He writes as follows: 'I, a native of Sheng-yang, in the province of Kuantung, whose family has for generations shared in the Imperial favour, since they followed the dragon standard to Peking, had my name enrolled at my birth in the Nei-wu-fu, the Imperial House-hold . . . Later, in the Autumn of the sixth year (1728) of the reign of Yung-chêng, in the eighth month, the late Prince of Yi conveyed to me, by word of mouth, the celestial orders, appoint-

100 A *famille rose* ruby-ground *garniture de cheminée*, of a type always popular in large European houses.

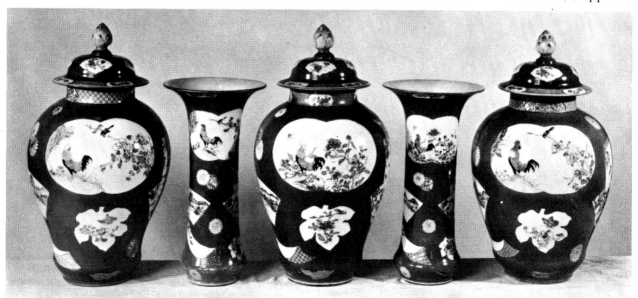

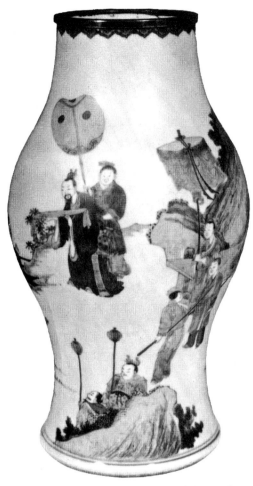

101 A Yung-chêng vase with *tou ts'ai* enamel decoration, bearing an apocryphal Ch'êng-hua mark.

ing me to superintend the porcelain manufacture in the province of Kian-si, and instructing me to relieve the workmen in cases of disease and trouble, and to encourage trade among the merchants ... Up to now, the cyclical year *yi-mao* (1735), I have been seven years engaged in the work ... An annual allowance (in addition to salary) of five hundred taels has been granted me for fuel and water, so my family subsists on the Imperial bounty, which a life's poor work could ill requite ... Although I dare not profess a complete knowledge of all the minute details of the ceramic art, yet I have practised it diligently for a long time, and am familiar with the official lists of the articles produced, with the composition of the glazes used in their decoration, with the designs and dimensions of the pieces, as well as with the wages and good of the workmen, their rewards for diligence, and their fines for negligence ... What I have carefully written, I know personally, and I submit it with deference to the officials that shall succeed me. The farmer may learn something from his bondman, and the weaver from the handmaid who holds the thread for her mistress'. Elsewhere he writes: 'When I was sent by Imperial decree in the sixth year of Yung-chêng to undertake the superintendence of the porcelain manufactory (as assistant to Nien Hsi-yao) I was unacquainted with the finer details ... I worked hard with heart and strength, and for three years shared with the workmen their meals and hours of rest, until in the ninth year of the cycle (1731), I had conquered my ignorance of the materials and processes of firing, and, although I dared not claim familiarity with all the laws of transformation, my knowledge was much increased.' After five more hot and cold seasons had passed by, during which 'his pottery vessels were not imperfect and the potter had not asked for sick leave', the accounts were made up to the thirteenth year of Yung-chêng, and it was found that, 'for an expenditure of several tens of thousands of taels of treasury silver, no less than between 3,000,000 and 4,000,000 pieces of porcelain, comprising all kinds of vases and round ware, had been sent up to the palace at Peking for the use of the emperor'.

It is thus seen that many of the improvements under the directorship of Nien Hsi-yao were more probably due to T'ang Ying, of whose porcelain it has been said, 'The paste of the pieces was white, rich and compact; the fabric, whether thick or thin, was brilliant and lustrous; and the Imperial porcelain attained at this period its greatest perfection'. A *clair-de-lune* vase formerly in the Bruce collection bears a poem signed by T'ang Ying. The bowl in the British Museum [figure 94] bears the Ch'ien-lung mark and must have been made under T'ang Ying. Like his predecessor he also copied the wares of the Sung and Ming dynasties. The new inventions of this period are not, however, so good. They took great delight in imitating other

73

102 An eighteenth-century figure of a hound.

materials such as jade, *cloisonné*, wood, bronze alloys, gold and silver, and however clever some of them are, the result appears displeasing. The emperor also asked for copies of European originals and Limoges enamels, Delft, and Italian majolica as well as Meissen, and even Wedgwood blue jasper-ware was copied. The retirement of T'ang Ying in either 1749 or 1753 (authorities disagree over this date) coincides with the end of the great tradition of Chinese ceramics. The later Ch'ien-lung pieces, though they show great powers of invention, are usually rather monotonous in design and mechanical in appearance. The bowls and vases are covered in thick, opaque glazes with *famille rose* decoration above; the insides of the lips and the bases are covered with an unpleasant turquoise green.

There is a small group of eighteenth-century Imperial porcelain which goes under the name of Ku Yüeh Hsüan (Ancient Moon Terrace) and which is of the finest quality. This name is also applied to a larger number of pieces of porcelain inscribed with these characters and decorated in fine Chinese taste with flowering plants and landscapes. Most of these latter pieces, however, are of later date and inferior quality. According to Hang Hsiao-k'un, who wrote a monograph on this subject in 1934, they originated under Ts'ang Ying Hsüan, superintendent for K'ang-hsi and the secret perished with the death of T'ang Ying. They are small pieces ranging from vases and bowls to dishes, the bowls being the least rare. They are often decorated with formal flowers on coloured yellow, blue and red grounds, the centres of the flowers sometimes with characters. Yang lists a hundred and twenty-three pieces, only three of which are decorated with figures.

Though the quality of the Imperial wares declined during the second half of his reign, the emperor Ch'ien-lung was at all times a great patron of the arts. He was very interested in the innovations of the Europeans and had a pavilion built copying the design of Versailles. He built up a large collection of European clocks and watches and also had a fine collection of Sung ceramics, many of which he had inscribed with his own poems. The export porcelain was still being made in very large quantities, the greater part being services for the table, often decorated with coats-of-arms or crests. Other pieces which are worthy of mention, though they do not follow the traditional forms, are the magnificent figures of birds and animals. These, originally enamelled on the biscuit during the reign of K'ang-hsi, reach full flower in the middle of the eighteenth century. The pair of pheasants [figure 129] show not only the magnificent sculptural effect of the design but also the brilliant colouring typical of the best of this type of production. All kinds of birds were made perched on rockwork bases including cooks, hawks, cranes and phoenixes, as well as other animals. Cats covered in

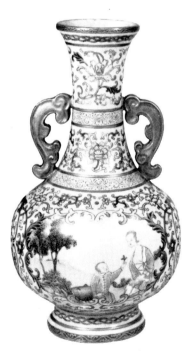

103 A Ch'ien-lung vase of a type popular in China at the end of the eighteenth century.

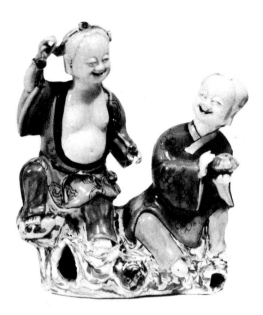

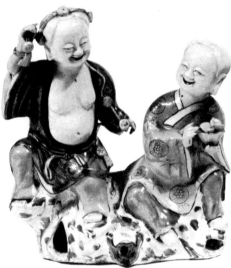

104 A pair of *famille rose* figures of laughing twins, called by the Chinese *Ho Ho Erh Hsien*.

pale blue glazes are amusingly shown as worried by the insects on their backs [figure 106], while the stag [figure 77] stands majestically defiant. Dogs of various kinds were also popular subjects [figure 102]. Figures of the deities were also in great demand and sets of the eight Immortals with their leader Shou Lao were made in quantities. By the end of the century, however, the quality had declined and they are often amusing and decorative rather than works of art. The pair of groups of boys [figure 104] and the large figures [figure 124] show typical examples of the figures made during the second half of the eighteenth century.

With the tremendous trade now being carried on with Europe, and with the clear judgment and iron will of Ch'ien-lung, the country was prosperous and happy. But the succession of his son Chia-ch'ing (1796–1820) coincided with the rising competition of the European china factories and with the growing power of the elements hostile to the Manchu dynasty. Chia-ch'ing was both stupid and cruel, and in the year he came to the throne a rebellion broke out in Hupeh which was not put down for eight years. The porcelain of his period follows that of the latter part of the reign of Ch'ien-lung. To both periods belong the openwork lanterns, the vases encrusted with plants and with squirrels amongst pines, and the so-called mandarin vases of thin porcelain painted with figures on terraces within iron-red Y-pattern borders. Throughout the reign of Chia-ch'ing and his successor Tao-kuang (1821–1850) there is a marked deterioration of the non-Imperial wares; the decoration becomes more perfunctory and mechanical and the paste coarser and greyer. There are, however, exceptions, and the yellow-ground bowl [figure 107] which bears the mark of Tao-kuang is not much inferior to an almost identical bowl in the British Museum of the Ch'ien Lung period. The decoration, however, on the Yung-chêng coral-ground bowl beside it is much freer and more attractive. At this time bowls with medallions on coloured graviata (incised with scrolls in the thick opaque enamel) grounds had become very

105 A late nineteenth-century punch bowl, enamelled at Canton and carrying a Persian inscription.

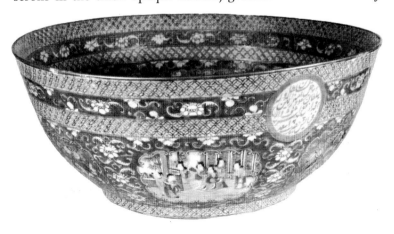

popular. The earliest date from the end of the reign of Ch'ien-lung and the latest from the end of the nineteenth century. The majority of the snuff bottles, also first made in large quantities during the latter part of Ch'ien-lung's reign, date from the nineteenth century. The copies of Yung-chêng and K'ang-hsi Imperial vases continue to be good. Tao-kuang had so much to do in combating the imperialism of the European powers and the rebellions fermented by the secret societies which were springing up all over the country, that he was unable to take any real interest in the porcelain factories. His successor Hsien-fêng (1851–1861) came to the throne only to find the whole of the centre of China in rebellion under the T'ai-p'ing. In 1853 Ching-tê-chên was sacked by the rebels. The rebellion was put down in the following year, but the kilns were not rebuilt until 1864. In 1856 the second Foreign War broke out, and the first Imperial porcelains reached Europe after the sack of the Imperial Palace. T'ung-chih, who reigned from 1862 until 1874, had the Imperial factories rebuilt with seventy-two buildings, but examples dating from this period are not of great interest. The reign was disturbed both by rebellions at home and further inroads into Chinese sovereignty by the Europeans.

During the reign of Kuang-hsü (1875–1908) copies of *famille noire*, three-colour enamels on the biscuit and peach-bloom porcelain continued to be made in the K'ang-hsi style. The best of these are very hard to tell from the original. It is probable that some of the large *famille noire, famille verte* and *famille jaune* figures and vases, so popular and expensive in Europe at the turn of the century, could have been made during this period. Kuang-hsü was dominated by the dowager empress Tz'û-hsi who took an interest in the Imperial factory and sent some Ch'ien-lung pieces to be copied. His successor Hsüan-tung was compelled to abdicate in favour of the Republic in 1912. In 1916 Yüan Shih-k'ai attempted to form his own dynasty with the title Hung-hsien, but this was unsuccessful. The modern potters are still turning out deceptive forgeries of the older wares, but up to recently have not produced any modern wares of quality.

106 A pair of eighteenth-century figures of cats, with pale turquoise glazes.

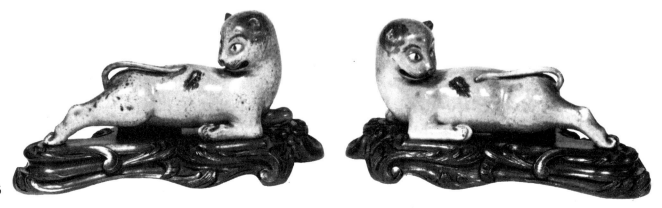

Chinese Export Porcelain

THE PORCELAIN MADE IN CHINA FOR EXPORT to the Near East and Europe deserves special mention. Much of it was totally different to that produced for the home market. Shards of T'ang pottery have been found occasionally on sites in the Near East, while quantities of inferior Sung celadons are still to be found in many places in the East Indies. In the British Museum there is a *ying-ch'ing* bottle with European silver mounts, while in the Bibliothèque Nationale in Paris there is a drawing of a ewer of similar date which roughly coincides with the arrival of Marco Polo at the Court of Kublai Khan during the Yüan dynasty. A number of the large blue and white vases, bowls and dishes of the late fourteenth and fifteenth centuries as well as similar pieces of celadon ware are to be seen at the Ardebil shrine in Persia and in the Topkapu Sorayi in Istanbul [figures 30 and 31], and these must have been exported to the Near East in fairly large quantities. Various merchants and explorers had reached China well

107 *(left)* A Yung-chêng bowl painted with flowering plants on a coral ground; *(right)* A Tao-kuang bowl with stylized foliage and flowers on a yellow ground.

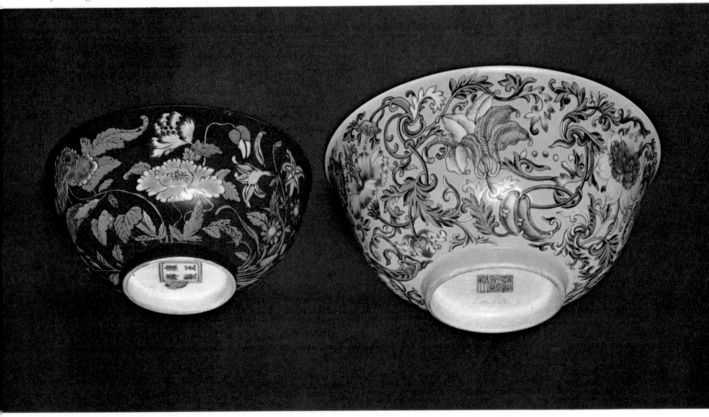

108 A Ch'ien-lung blue and white tureen copying a European faience original.

109 A *famille verte* octagonal vase, with purely Chinese decoration, but shaped to please European eyes.

before the birth of Christ, but it is not until the first century AD that historians and geographers begin to talk about China. One of the earliest trade routes appears to have been the sea route from Canton to Ceylon and thus to the Persian Gulf. The other route was the Tartary road through Poland, past the north end of the Caspian Sea, and on through Mongolia. There were a number of Europeans living at the court of the Grand Khan in Karakorum.

The first serious traders, however, to reach China from the West were the Portuguese, who having established themselves at Goa and Malacca with several expeditions between 1500 and 1506, now started to explore the routes to Cathay. A certain Jorge Alvarez was the first to reach China in 1514, and the following year a second expedition arrived at Canton. In 1516 another expedition under Bernao Peres de Andrade was formed, accompanied by an ambassador to the emperor, Tomé Pirès. The latter did not reach Peking until 1521. In the meantime Bernao's brother Simao had led another expedition which took Tunmen by force, but was subsequently put to flight. Two more unsuccessful expeditions were handled badly and the emperor issued an edict forbidding the entry of the bearded, large-eyed men. Poor Pirès was thrown into prison on his return to Canton and all official trade was stopped. However, the business having proved so profitable, the Cantonese merchants made unofficial arrangements to trade. The Portuguese then started trade fairs on the deserted islands off the coast from July to November each year. This region was infested by pirates, and eventually, in exchange for the Portuguese offering to control the bandits, the emperor offered them the promontory of Macao, which they have held ever since. The earliest pieces of blue and white porcelain with specifically European decoration were made for the Portuguese market. The earliest known piece is a ewer with an armillary sphere, the emblem of King Manuel who died in 1521, the same year as Chêng-tê. The pieces bearing the reign-mark of the latter, decorated with inscriptions in Arabic, are

110 A Ch'ien-lung tureen in *famille rose*, with an English coat-of-arms.

112 A late Ming *kendi* in blue and white made for export to South-east Asia.

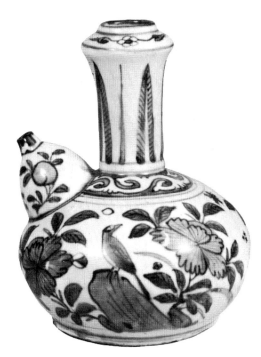

111 A pair of large vases, with painted harps on an emerald-green ground, made for the Irish market about 1780.

considered more likely to have been made for Moslem members of the court than for export to the Near East. In the sixteenth century very little porcelain had reached Europe and the simple cup [figure 44] was considered so rare that it had elaborate silver mounts added when it reached Europe.

The Spanish had meantime reached the Philippine Islands, where they established trade bases, from which they tried somewhat unsuccessfully to wrest the Chinese market from the Portuguese. On the other hand, when Philip II, King of Spain and Portugal, closed the port of Lisbon to the Netherlands after their successful revolt in 1594, the Dutch decided to try to buy direct from China. In both 1602 and 1614 Admiral Van Heemskirk managed to capture a carrack loaded with goods; in the latter year it was the *San Caterina,* which was almost entirely full of porcelain and was sold at Amsterdam. As a result the Dutch East India Company was founded, and made its base at Batavia, now Djakarta, the capital of Indonesia. Being refused permission by the Portuguese to trade from Macao, they went to Formosa from where they traded with Japan and with unimportant Chinese towns on the coast. In spite of these difficulties they managed to do more and more trade throughout the seventeenth century. The English established their East India Company in 1599, but did not arrive in China until 1631. Their share in the trade of the seventeenth century was comparatively small.

The export porcelain of the late sixteenth and early seventeenth century was almost entirely blue and white of rather inferior quality. On the Continent it is called 'Carrack' porcelain, after the Portuguese ships which were used to transport it to

114 *(opposite)* A large mid-eighteenth-century *famille rose* rose jar. The scroll panel is painted with figures, and the border with flowering branches.

Europe. It consists of plates, dishes, vases, bowls and ewers, often painted with birds, deer or flowers in small panels, the borders with tiny petal-shaped panels of flowers. The paste is very thin and grey with black spots, the decoration is greyish-blue, and the foot rims often have sand adhering to them. But early in the seventeenth century the work of the artist-potters began to appear decorated in blue and *wu ts'ai* colours. These were normally decorated with flowering plants, boys at play and Buddhist lions sporting, occasionally with iron-red trellis or scale pattern grounds. Most common are the jars which were probably used to transport the tea from China to Europe, as tea-drinking became fashionable. Other forms include dishes of saucer form, slender cylindrical vases, beakers and bottles, as

113 A painting by Jan Verkolje of Europeans drinking tea from imported Chinese porcelain.

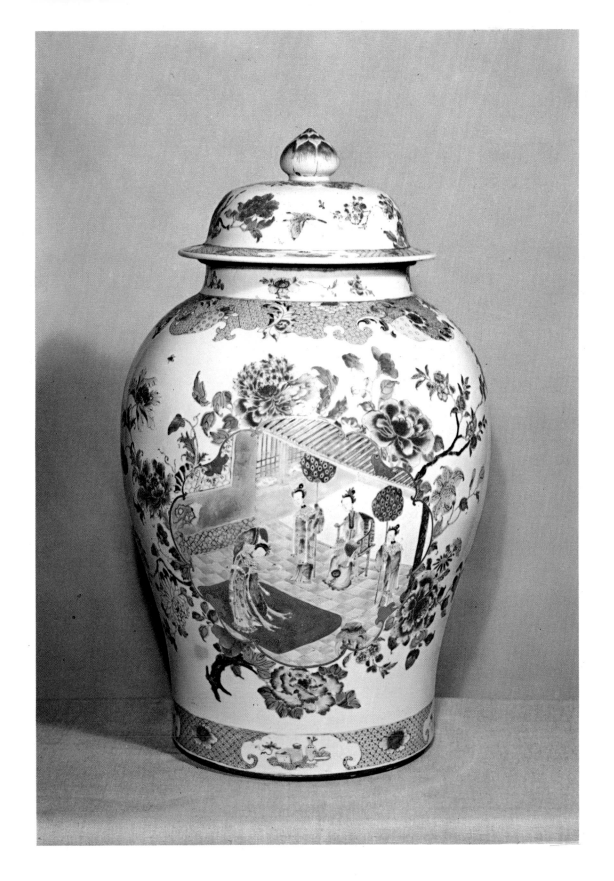

well as copies of European originals such as tankards. These were probably made from wooden models sent to China by the Dutch in Formosa. In spite of the difficulties of dealing with the mandarins who considered all Europeans to be foreign barbarians and unworthy of contact, and in spite of the stupid trade practice of the Dutch and Portuguese in blackening the characters of their rivals in their efforts to win sole trading rights with the court of Peking, the natural curiosity and business acumen of the Chinese merchants ensured that trade would increase. From the records of the various East India Companies it is possible to see how the trade grew. In 1637 The East Indiaman *Catherine* included in her cargo fifty-three tubs of china; in 1724 the *Macclesfield* included about a hundred and fifty chests; and ten years later the *Howard* and *Grafton* brought home 240,000 pieces in 240 chests. The Danes imported approximately the same amount, and the French and Dutch about a hundred and sixty chests each. One can see that in one year alone well over a million pieces of Chinese porcelain were imported. The trade reached its height between 1760 and 1780, when it declined owing to the fact that the market was too well supplied and to the increasing competition from the newly developed European factories. By the early nineteenth century, Worcester, Derby, Coalport and the many Staffordshire factories were producing such quantities that the English trade had almost ceased, while the new cheap creamwares of Wedgwood and Leeds were making great headway on the Continent. The Americans, however, still found it advantageous to trade with China, and

115 A Ch'ien-lung *famille rose* figure of a Dutchwoman with a squint.

117 A Ch'ien-lung *famille rose* punch bowl with a view, probably of Versailles.

118 A Chinese Jesuit plate, with a painting of the Ascension reproducing an early eighteenth-century European print.

there are a number of pieces decorated with American motifs and dating from about 1800 which are highly prized across the Atlantic.

A great number of the late seventeenth-century and early eighteenth-century pieces are of a purely Chinese type which happened to please the European taste of the period, but gradually orders began to creep in for special pieces and shapes. Silver coffee and tea pots, caddies, sauceboats and other table pieces were copied in porcelain. Coats-of-arms were sent out to be copied. There is the famous story of the Channel Islander who ordered a Chinese dinner service with his coat-of-arms enamelled in the centre, whose agent had carefully written against the sketch of his arms the words 'green', 'blue', and 'red', only to find a year later when the service reached him, that the Chinese artisans, not understanding what was written, had copied the words as well as the colours. The most popular of all forms in the early part of the eighteenth century were the bowls, cups and saucers as well as the plates and dishes. The tureens were at first either round or oval [figure 110], but as the century advanced they became of oblong octagonal form and later still of oval classical form. In the middle of the century one occasionally comes across examples copied direct from a European silver or faience original [figure 108]. Sets of five vases for the chimney were very popular; these consisted of three vases and covers together with two beakers. As well as the enormous dinner, tea and coffee service for the table, many toilet services were ordered including ewers with basins, chamber pots and pomade pots. 83

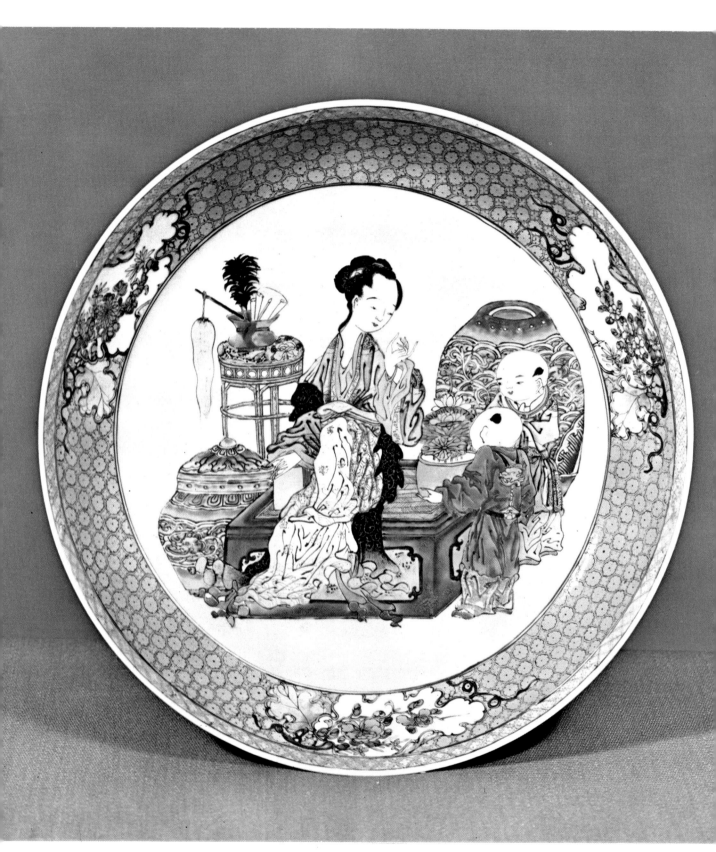

119 *(opposite)* A *famille rose* eggshell saucer dish with a ruby back. The centre is painted with a lady and children, and the borders are brocaded.

120 A Ch'ien-lung *famille rose* pilgrim bottle with birds on flowering branches in the Chinese taste.

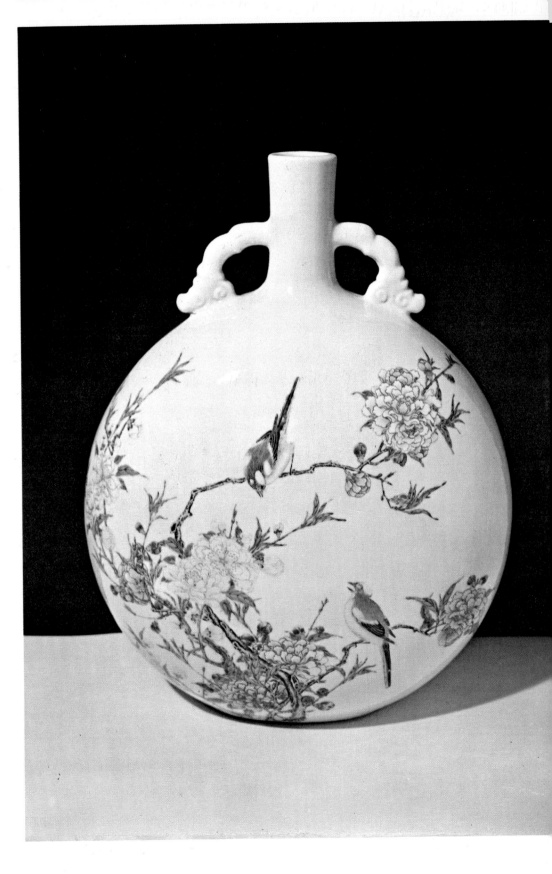

121 and 122 *(above and opposite)* Chinese fans painted with views of the European 'factories' at Canton, with national flags flying.

The European subjects were also greatly copied. The Jesuit missionary Matteo Ricci took out with him in the seventeenth century a collection of prints of illustrations from the Gospels published by Père Nadal in Antwerp at the end of the sixteenth century. But it is not until the reigns of Yung-chêng and Ch'ien-lung that the so-called 'Jesuit' porcelain is found. These are a series of plates, dishes, cups, saucers and other tea-ware, very finely painted in black and gold enriched with flesh tints, usually depicting religious subjects, such as the Crucifixion and the Ascension [figure 118], so close to the original that one could mistake them for transfer prints. The Jesuits who had earlier enjoyed the confidence of the emperors found themselves persecuted more and more as the eighteenth century advanced; their churches were closed and the monks were either executed or imprisoned. The only exceptions were the Jesuit fathers

Candlesticks are more rare and almost always copies of silver originals; even more uncommon are wall lights, mirror frames and plaques intended to be inset in pieces of furniture. Copies of European porcelain originals started to be made in the second half of the century. The Dutch Dancers [figure 128] was a model first made by Eberlein at the Meissen factory. It proved very popular in England and was copied at Bow, Chelsea and Derby as well as in China. The Dutch lady [figure 115] and the dancing couple [figure 116] are, however, pure Chinese ideas of how the Europeans appeared to them from the prints which were beginning to pour into the country. One occasionally comes across copies of Delft pottery cows and Meissen dessert baskets supported by children round a tree stump. The tureens in the form of boars' heads, partridges and other animals and birds are almost certainly taken from European originals.

living in Peking who were allowed to remain more because of their scientific and artistic knowledge than their religious teaching. It is often somewhat difficult to recognize the source from which the Chinese copy is taken. The subject is usually very much simplified and the figures become stiffer; sometimes the impact of the print is completely lost as one of the main components has been left out. The Cherry Pickers, after a picture by Baudouin, is a favourite subject and must have been very popular in the eighteenth century as Kändler used it for one of his models at the Meissen factory. Classical subjects were also popular and

123 A Ch'ien-lung *famille rose* plate decorated with an unconsciously comic version of kilted Scotsmen.

88

there can be seen two magnificent dishes in the British Museum painted in black Chinese ink, one with Achilles being dipped in the river Styx, which are so exactly copied that one would not have guessed that they were made in China. The Judgment of Paris is another favourite subject that occurs fairly often, as well as a series emblematic of the Elements with classical figures in

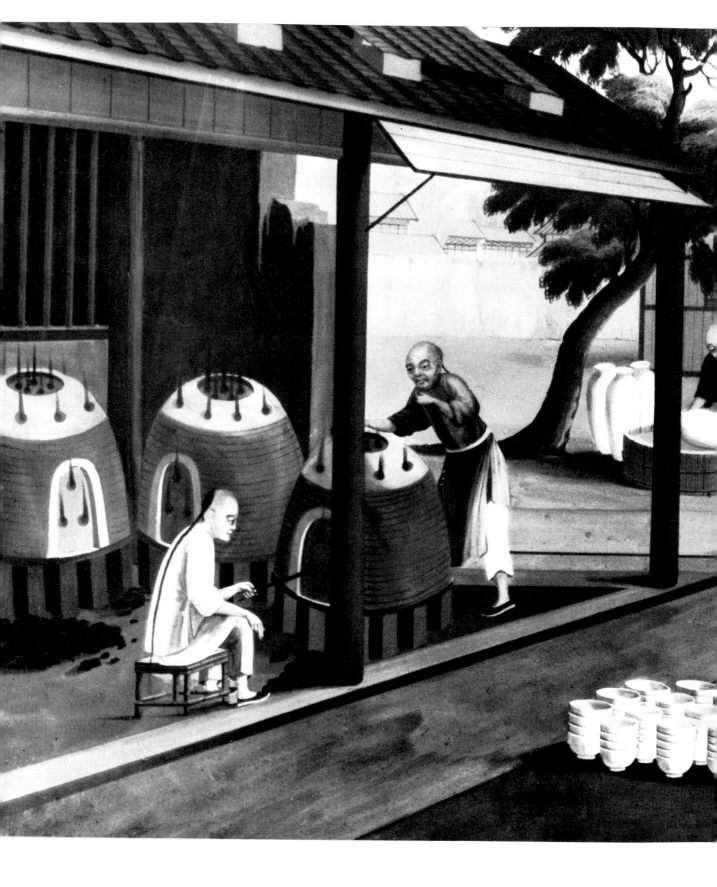

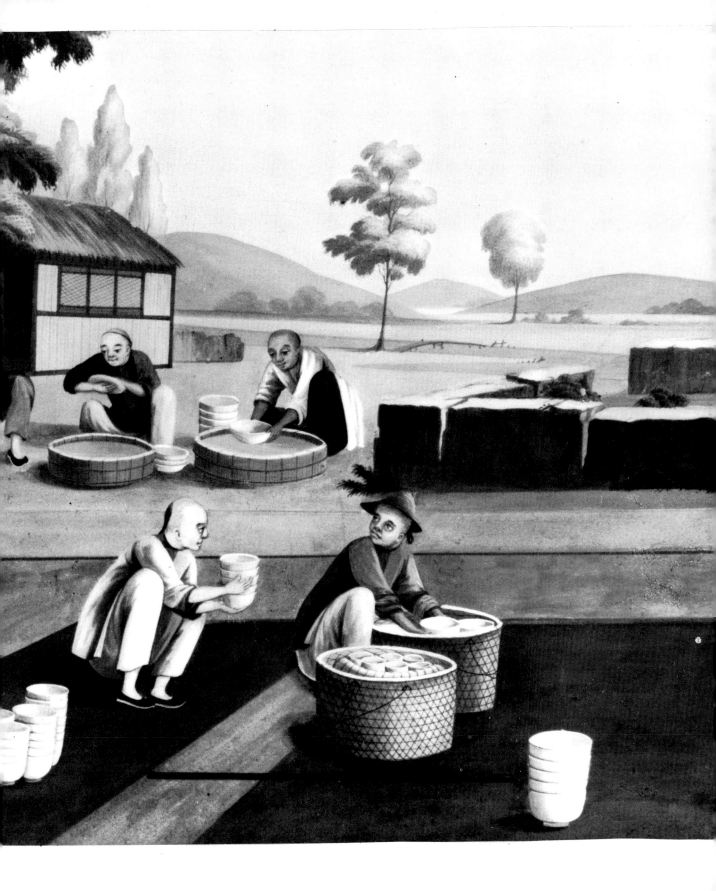

128 A Chinese group of Dutch or Tyrolean dancers, after the Meissen original by J. F. Eberlein.

126 An early eighteenth-century Chinese plate from a dinner service made for a member of the Clarke Jervoise family, and painted with his armorial bearings.

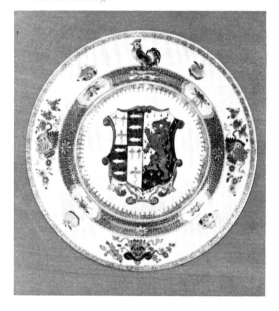

127 A punch bowl showing a hunting scene taken from an English print. Ch'ien-lung *famille rose*

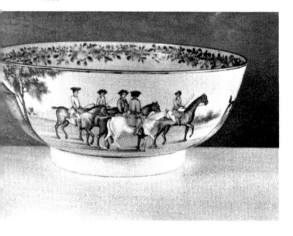

chariots, based on seventeenth century originals by Amiconi. Subjects from contemporary novels and literature also appear. The large bowl [figure 117] has a view of Versailles on the one side and what may be Vauxhall Gardens on the other. Much of the porcelain was commissioned by the officers of the ships which called at Canton and many pieces are decorated with representations of their ships. Lord Anson, who called in at Canton in 1744, ordered an armorial service with panels showing the ports of Plymouth and Canton and painted with the breadfruit plant. The English were very fond of hunting and other sporting subjects. The punch bowl [figure 127], painted with 'The Meet', is a fine example of this type of decoration taken directly from a print. More rarely one comes across scenes of horse-racing and cock-fighting. Political subjects appear, and there are number of pieces with Jacobite or Masonic emblems on them. Punch bowls inscribed 'Wilkes and Liberty' are also found. The plate painted with the two Scotsmen [figure 123] is of a type that must have been popular north of the border. Don Quixote in armour riding his horse, Dutch peasants skating, gods, goddesses, politicians, good men and bad, all make their appearance, often with an amusing Oriental caste to their features. The Chinese were prepared to copy all that was sent to them, but often they did not have any idea of what it was meant to represent.

Apart from the early blue and white pieces for the Portuguese market, the pieces with armorial decoration did not appear until towards the end of the reign of K'ang-hsi. Up to his time the

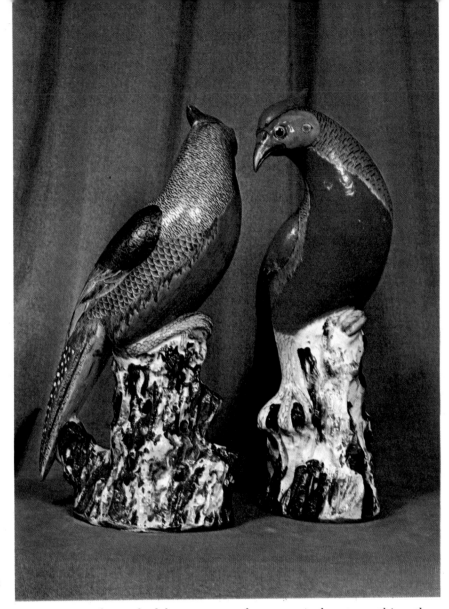

129 A pair of Ch'ien-lung pheasants in vivid enamels.

merchants had been prepared to accept almost anything they were offered, but with the increasing competition more and more precise orders came through, not only for particular types and sizes of services, but also for services with the family arms on them. At first the whole of the centre of the plate or dish was taken up with the arms and elaborate mantling, while the border remained in the typical Chinese style. In the early eighteenth century, the arms became slightly smaller [figure 126] and as the century progressed, they were often relegated to the border to allow the centre to be otherwise decorated. With the advent of neo-classicism towards the end of the eighteenth century, the pieces were often very sparsely decorated with either a crest or a monogram in a shield and with almost jewelled borders. At the very end of the century it was common practice to have

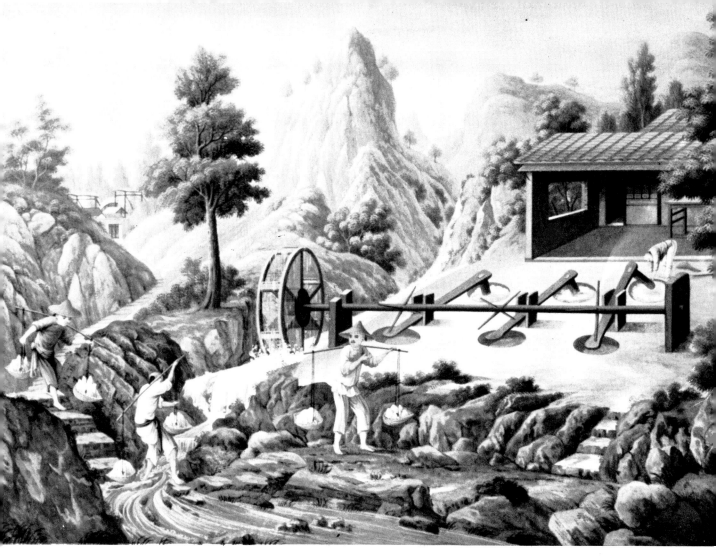

services elaborately decorated in underglaze blue with the 'Fitzhugh' or similar designs (a combination of trelliswork and scrollwork panels round the border enriched with butterflies, flowers and key-fret), with the arms or crest enamelled at Canton. In the nineteenth century the services are usually very coarse and over-decorated with numerous figures in court scenes on gold grounds enriched with flowers, birds and insects.

Apart from the Jesuit priests at the emperor's court, life was still very difficult for the Europeans residing in Canton. All the business had to be finished before the end of the year, so that the ships homeward bound could catch the monsoon wind. Every ship which docked had to pay customs duty dependent on its length, as well as a levy to be sent direct to the emperor. On land they were restricted to the quarter where their factories (warehouses) were built, the Chinese were forbidden to teach the Europeans their language, and any contravention of the law by a European was severely punished. Figures 121 and 122 show

130, 131, and 132 These three illustrations, taken from a nineteenth-century set of drawings in the British Museum, show three different phases in the manufacture of porcelain.

two sides of a fan painted with a view of the factories and the flags of the various nations flying above them. In the eighteenth century there were eight nations with factories in Canton – Holland, England, France, Sweden, Denmark, Spain and later the U.S.A. and Greece. Portugal, of course, traded from Macao. In the early nineteenth century the number increased to thirteen, but all were destroyed in a great fire in the nineteenth century. There were only about ten official Hong merchants authorized to deal with the Europeans. It was these merchants who went to Ching-tê-chên with the orders from Canton. Lord McCartney was sent as ambassador to Ch'ien-lung in 1792 to try to obtain better living conditions, but all his overtures were refused. A few years later the power of the English had increased and the Chinese, troubled by internal rebellions, were forced to relax their laws little by little. The interest of the Europeans was by now more imperialist and there was no longer great interest in the porcelain productions.